DRAWING
AND SKETCHING
GERALD WOODS

LEOPARD

KU-746-113

DRAWING AND SKETCHING

WITHDRAWN FROM STOCK

Leading
Acc. No.
Class No.
Inv. No.

CLB 4079

This edition published in 1997 by Leopard, a division of
Random House UK Ltd, Random House
20 Vauxhall Bridge Road, London SW1V2SA

Copyright © 1995 CLB International, Godalming, Surrey

All rights reserved

ISBN 1 85170 560 0

This book was designed and created by The Bridgewater Book Company Ltd
and produced by CLB International
Designers Peter Bridgewater / Annie Moss
Editor Viv Croot
Managing Editor Anna Clarkson
Photographer Zul Muhkeda
Typesetter Kirsty Wall

Acknowledgements
We would like to thank the following artists for their contribution to this book:
Kate Davies page 19; Harold Cohen pages 50-1; Sophie Mason page 53

Printed and bound in Spain

Contents

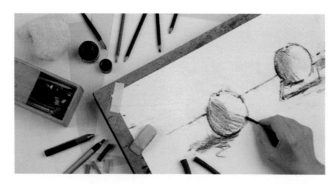

WITHDRAWN FROM STOCK

At-A-Glance Guide

Introduction

Looking out of the window of my top floor study, I can just see the distant horizon of the sea. If I wanted to render this view in terms of drawing, I would have to use a line to describe it. A drawn line, however, has no physical existence – it is not actually part of the sea, it can only be a symbolic gesture made with a pencil to represent the limits of my vision. But having drawn the horizon, I would need to include other points of reference in my drawing.

It was Delacroix who said that one line alone has no meaning; a second one is needed to give it expression. If my drawing is to communicate anything at all, therefore, I would need to draw the rooftops which appear to diminish in size as they recede towards the horizon. To convey this sense of recession, I would need to have some knowledge of perspective. Furthermore, if I wanted to create the illusion of three dimensions, I would need to develop the drawing tonally in terms of light and shade.

This may sound quite complicated but learning to draw is like learning a language – drawing is the language of the eye. Just as with spoken language we must first get to grips with grammar and then begin to enlarge our vocabulary, so with drawing we must first learn how to represent an object in three dimensions, to relate the object to its background and to show how objects relate to one another in space. We can then begin to enlarge our visual vocabulary by using sketchbooks to make prolonged studies and brief notations of chance scenes or fortuitous arrangements of objects which may catch our interest.

In my view, the first principle of producing a successful drawing is to be

open to discovery. A person who draws frequently from observation becomes more visually aware than someone who does not. Thousands of tourists visit the church of Santa Maria della Salute in Venice, for instance, but I feel that I know that building better than most people, because in the process of trying to register all the proportions of the structure in my drawing, my powers of concentration have necessarily been more intense than those of the casual observer. By concentrating on developing precision of observation you can arrive at technique, but you can never become more visually aware by concentrating on technique alone.

This is not to suggest that technique is not important, indeed the more control an artist has over a medium, the better he or she will be able to communicate effectively. Drawing in pencil, charcoal, pastel or any other medium is part of a process – a means of conveying your response to a particular subject. What is required, therefore, is that you should be able to control your chosen medium with sufficient fluency to produce drawings which evoke the essential qualities of the things you draw.

The first part of this book is devoted to the various materials and techniques at the artist's disposal. The exercises which follow are intended to build up confidence in handling a wide range of media. The techniques section of the book is essentially concerned with drawing from direct observation. Line and tone, measured drawing, perspective and composition are dealt with in terms of their application to subject-matter such as landscape, architecture, figure-drawing and nature studies.

In the Project Section of the book the author and two other artists demonstrate how the same subject is open to different interpretations. The critique which follows each project might, one hopes, encourage the reader to produce drawings which are very much better!

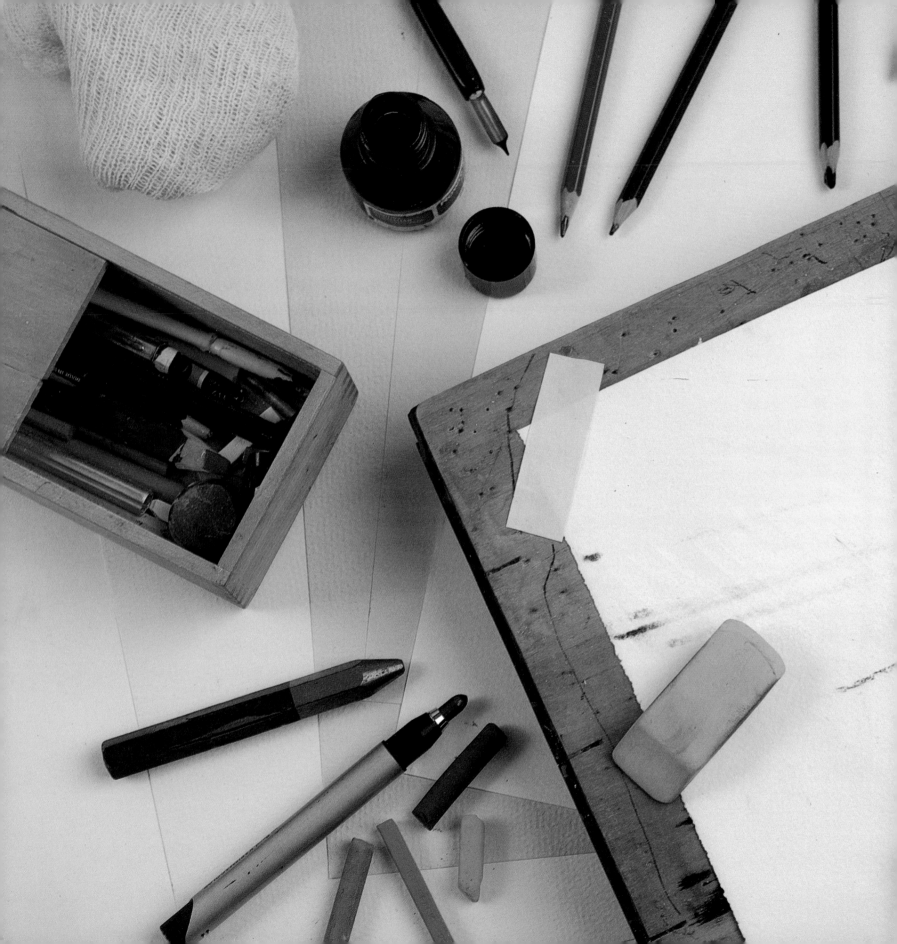

MATERIALS AND TECHNIQUES

Pencils

Michelangelo said that it should be possible to distinguish one artist's work from another by the way he drew a single straight line. The quality of line is critical in drawing, since it bears the imprint of an emotional response to the subject. When an artist develops an affection for a particular person, object or place, his or her feelings are most intimately transmitted through his or her drawings.

Most artists, in fact, tend to pick up a pencil without bothering to notice whether or not it is of a hard or soft grade in an effort to capture an idea spontaneously before the impression fades. It is precisely this kind of response which can invest a drawing with the vital resonance that separates it from a technically competent but otherwise stilted drawing.

Wood-encased graphite pencils range from the softest 9B to the hardest, 9H. In the manufacture of pencils, the graphite forms the pigment, and the clay the binder. The larger the proportion of graphite, the softer and blacker the pencil. Hard pencils have a higher proportion of clay. The materials are finely ground, pressed and fired before being inserted into their casing, usually made from cedar wood.

The soft B grade pencils allow for a greater sensitivity of line and are capable of rendering rich gradations of tone. The darkest B grades produce an intense, gritty black which is best used on a textured drawing paper. Some artists successfully combine hard and soft grades of pencil in producing a single drawing, the hard lines being employed as a kind of underdrawing and the softer lines overlaid to emphasise the main accents.

Coloured pencils are useful for producing half-tones in contrast to darker tones made with a graphite pencil.

The colour and tonal range of a drawing can be extended by using different types of pencil.

Aquarelle pencils can be used dry, or can be partially dissolved with a brush loaded with water to produce a grainy wash.

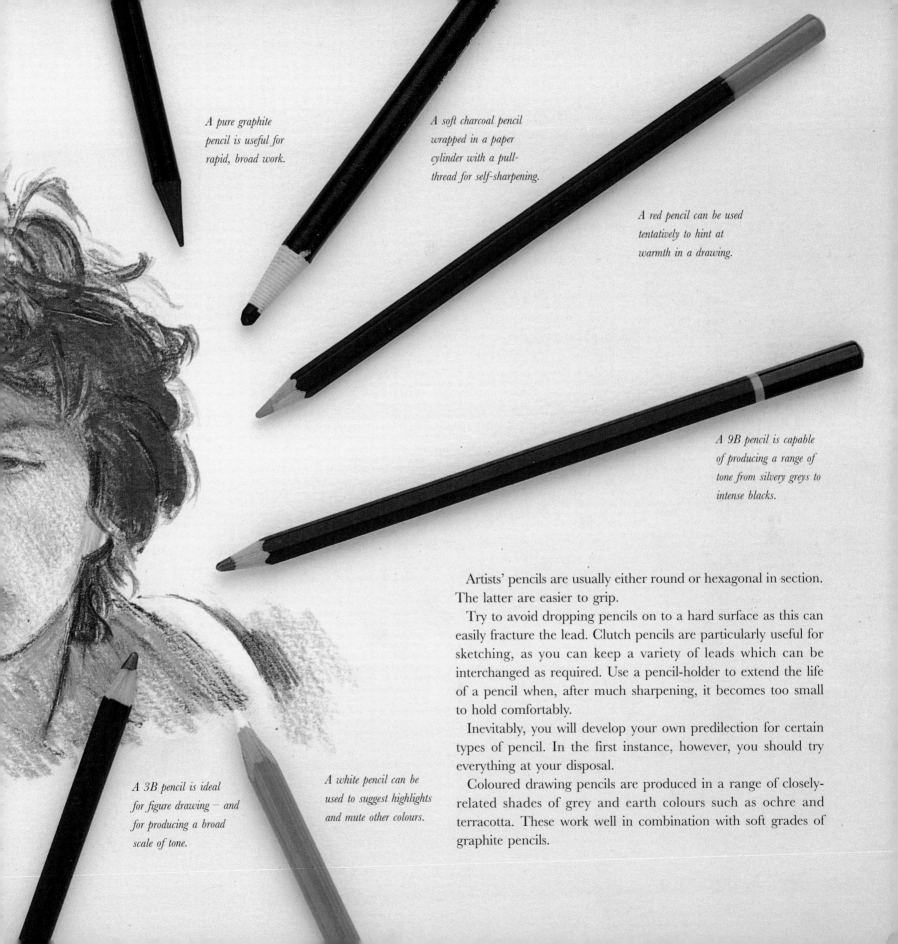

*A pure graphite
pencil is useful for
rapid, broad work.*

*A soft charcoal pencil
wrapped in a paper
cylinder with a pull-
thread for self-sharpening.*

*A red pencil can be used
tentatively to hint at
warmth in a drawing.*

*A 9B pencil is capable
of producing a range of
tone from silvery greys to
intense blacks.*

*A 3B pencil is ideal
for figure drawing – and
for producing a broad
scale of tone.*

*A white pencil can be
used to suggest highlights
and mute other colours.*

Artists' pencils are usually either round or hexagonal in section. The latter are easier to grip.

Try to avoid dropping pencils on to a hard surface as this can easily fracture the lead. Clutch pencils are particularly useful for sketching, as you can keep a variety of leads which can be interchanged as required. Use a pencil-holder to extend the life of a pencil when, after much sharpening, it becomes too small to hold comfortably.

Inevitably, you will develop your own predilection for certain types of pencil. In the first instance, however, you should try everything at your disposal.

Coloured drawing pencils are produced in a range of closely-related shades of grey and earth colours such as ochre and terracotta. These work well in combination with soft grades of graphite pencils.

Charcoal

14

ABOVE *A 30-minute
study using willow
charcoal and chalk
pastel.* BELOW *A study
in charcoal and chalk
pastel of Michelangelo's
'Bozzetto the Slave'.*

Charcoal drawing is an ancient medium still very much in use today. Unfortunately, the characteristically soft mark charcoal leaves on the paper has the disadvantage of being generally unstable, which is why so few examples produced by the early masters survive.

The best charcoal is produced from slow-burning sticks of willow. The supply of air during firing is restricted, allowing the sticks to retain their individual shape. Artists' charcoal is produced in four different thicknesses: thin, medium, thick and scene-painters. The thin and medium sticks are best sharpened by breaking the stem. Thicker pieces can be rubbed against a sandpaper block to produce a sharper edge.

It is a medium capable of producing drawings of great sensitivity responding, as it does, to the slightest pressure. You will discover, for instance, that as your drawing progresses, you will tend to disperse the first marks you have made as your hand brushes against the surface of the paper. This means that you are constantly having to re-state the drawing in order to achieve the right tonal balance. Alternatively, the drawing can be fixed in stages (see page 24).

Thin papers with a slight grain such as Japanese paper or Ingres are best for charcoal drawing. It is, in my view, a good medium for the beginner in that it is easily corrected and helps to build up confidence in a way that would prove more difficult with a sharper instrument. There is a tendency, however, for some artists to deliberately smudge the charcoal in a dramatic way which only serves to conceal what may well be an underlying weak drawing or indifferent composition.

I am always telling students that they should try to work in terms of the medium. This is especially true in charcoal drawing. It is no good, for example, trying to produce the kind of detail that you would expect from the sharpened point of an HB pencil. Use charcoal for working broadly on large sheets of paper.

Compressed charcoal is more consistent in texture and is produced both in stick form and as a range of graded pencils. When fixing charcoal drawings, hold the spray at the correct angle and recommended distance from the drawing. If you spray too closely, you will disperse the pigment.

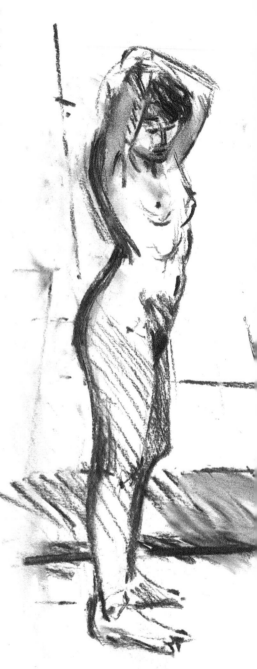

*Full-length figure study
using charcoal.*

Pencils and Crayons

Study in charcoal and chalk pastel of Michelangelo's model for David.

Coloured pencils are now produced in a range of well over a hundred colours. They are easily blended together to produce rich tonal qualities. They can be sharpened to a fine point like graphite pencils, or used bluntly to cover larger areas.

Aquarelle pencils can be partially diluted with a paintbrush dipped in water, producing a kind of mixed-media effect of pencil and water-colour. A certain amount of premeditation is required to get the best use out of these pencils. There is no point in diluting the pencil mark, for instance, if it simply destroys the tonal value of the drawing.

CONTE CRAYONS

Conté crayons produce an even line which is more intense than charcoal but more difficult to erase. It is, however, a more stable medium and is particularly useful for working on location. Sanguine conté is, as the name suggests, a red ochre and can be used effectively on a toned paper or in combination with black and white conté.

ABOVE *A tentative drawing using blended tones of coloured pencils and graphite.*
BELOW *A rapid life study drawn with a Burnt Umber crayon.*

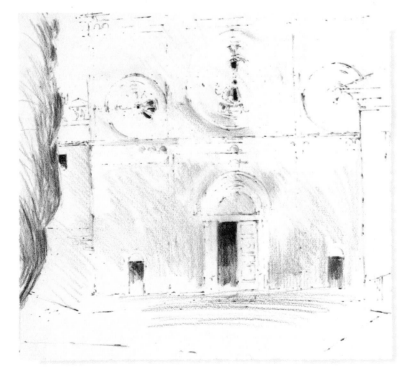

ABOVE *A 5-minute study using coloured pencils and graphite.*
LEFT *Study of a church façade using coloured crayons and graphite.*

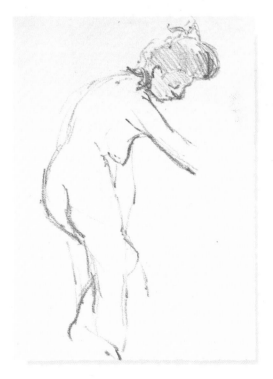

Pen and Ink

A woodland stream drawn on hot-pressed paper with a reed pen. Dry brush work is used to produce a variety of line and texture.

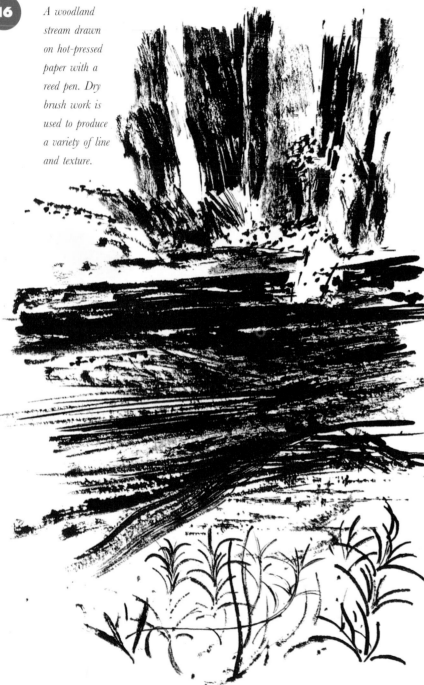

Imagine that you are using a fountain pen to write to a friend giving instructions how to get to your home. You would probably include a roughly drawn plan of the main roads, notable buildings and landmarks. This would be done quite spontaneously and without evident skill. If, on the other hand, you were asked to produce a pen and ink drawing of your house for framing, I feel that the quality of the drawing would be quite different from the sketch in your letter. The problem that most often confronts people when they start to draw in pen and ink is that the technique somehow gets in the way. A pen drawing by Rembrandt, for example, appears to flow from beginning to end with one sustained impulse. When drawing with a pen, therefore, you should try to use it as you would when writing a letter, using natural movements of the hand, without being overly concerned with techniques such as cross-hatching.

The earliest pens were cut either from goose and turkey quills or from reeds and bamboo. Such simple tools can be very effective. Van Gogh produced some of his finest drawings using a simple reed pen with sepia ink on a toned paper.

The traditional dip pen with a metal nib is most favoured by artists. These pens prove to be more flexible for drawing and offer a much greater variety of line than technical drawing pens, which produce a line of uniform thickness.

Dip pens should be used with Indian ink or inks which have a high degree of pigmentation. Dye-based inks and non-waterproof inks are attractive but the colours are often fugitive. There are some watercolour inks based on modern synthetic and organic pigments which have a high degree of permanence.

Pens which have a felt or plastic tip are now widely used and have improved in quality in recent years. They are capable of producing a fluid line without having to be continually recharged with ink. They are particularly useful for rapid notations in sketchbooks. The quality of line is more regular than that of a dip pen, but less mechanical than a technical drawing pen. Some of the brush-tip pens produce a softer, more sensitive line.

All these pens are worthy of your consideration and you should carry out your own experiments, making trial marks on scraps of smooth paper.

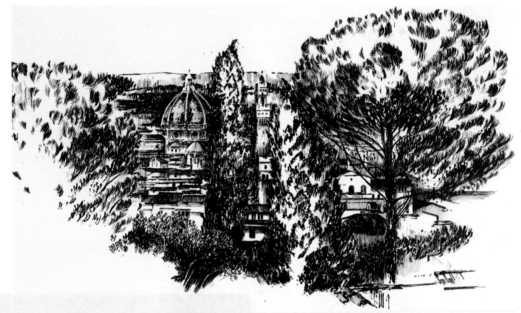

A view of the Duomo in Florence, drawn with a Gillett's 'Excelsior' legal nib and waterproof black ink on Basingwerk parchment.

BELOW *A girl in Greece drawn rapidly with a fountain pen.*

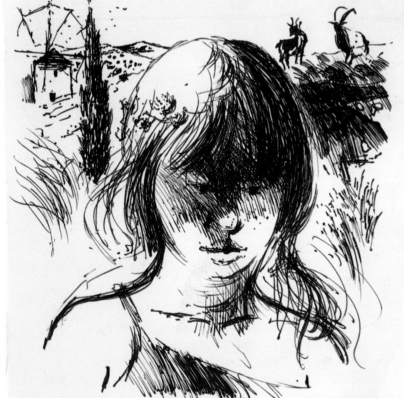

A drawing in pen and grey wash to accompany the poem 'Moonrise' by C. H. Sisson.

Pastels

Pastels have been used for drawing since the 15th century, when artists of the Renaissance used a combination of black, white, sanguine and pink chalks on coloured paper to develop preparatory drawings for fresco painting.

Today, pastel is considered to be the most 'painterly' of drawing media available. Furthermore, it lends itself to rapid and immediate use. The blending of colour is part of the drawing process. It is essential that one should appreciate how colour values are established in an additive way by blending, and not (as with oil painting) pre-mixing.

I would advise anyone beginning to draw with pastel first to take the time to look at reproductions of pastel drawings by Degas. As well as being a master of the medium, he was a great innovator, demonstrating superb technical control.

Soft chalk pastels are made from coloured pigment bound with gum and white filler. The shape, size and degree of softness varies with different manufacturers, but the best artists' pastels tend to be rather crumbly and fragile. Hard pastels are less expensive, but lack both the subtlety and intensity of soft pastels.

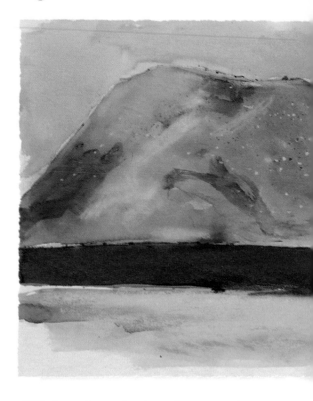

ABOVE *A portrait drawn in charcoal and closely-related tones of chalk pastel on pure cotton paper.* RIGHT *A study made directly from observation using blended chalk pastels and watercolour.*

Exercise with chalk pastels. The blocks on the far left explore colour values. Those on the near left show techniques of opposing strokes and blending with a torchon.

There are more than 500 tints of pastel colours in a complete range. The tints are distinguished by the proportion of white filler that is added to pure colour pigment. I would advise the beginner to start drawing with a basic set of colours; or better still, six colours of the same hue, plus white.

Pastel is a very tactile medium. Colours can be merged and blended by burnishing with a finger or by using a tortillon or torchon (a tight-roll paper twisted to a sharp point). In drawing a landscape, for instance, you might find that you need to soften the edges of the colour in order to capture the atmospheric qualities of a particular scene. Tones can be partially modified or removed altogether by using a hog's hair brush.

The choice of paper is critical since pastel requires a 'tooth', or pronounced grain, to retain the chalk on the surface. Toned papers such as Canson or Ingres are ideal. As with charcoal, the drawing can only be made stable by fixing. Again, this can be done in stages or when the drawing is completed. Spray with restraint – too much can impair the brilliance of the colour.

Oil Pastels

Oil pastels are very different in character to chalk pastels. They are soft, more pliable and more intense in colour. The smooth texture of oil pastels makes the blending of colour easier to handle. Colour can be scraped away with a flat blade and reworked until the right balance is achieved. Layers of oil pastel can be built up until they become too thick or smooth to accept further strokes of colour.

Parts of the drawing can be thinned with a brush dipped in turpentine substitute to produce a wash-like effect. The finished drawing will remain tacky until it dries and hardens. Any unwanted pigment can be removed by gently burnishing the surface of the drawing with cotton wool.

19

LEFT *Life study drawn with blended chalk pastels on cartridge paper.*

ABOVE *Exercise using oil pastels. Notice the softer tones produced by burnishing one colour over another.*

BELOW *Life study in chalk pastel using closely-related earth colours on toned paper.*

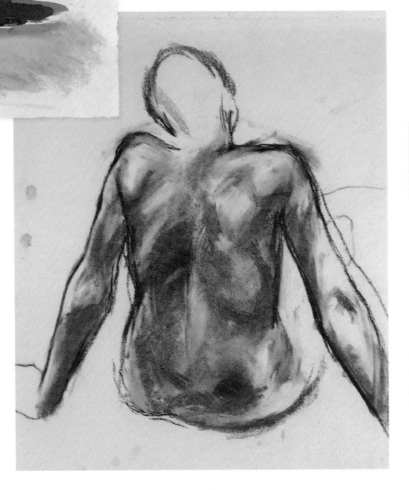

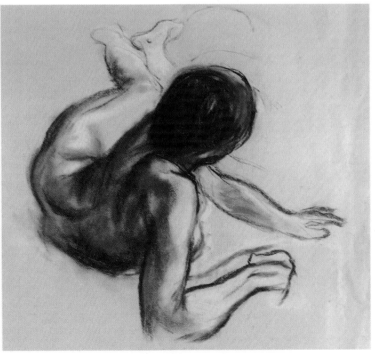

Brushes for Drawing

" *He painted and wrote with joy.* The Chinese artist Wu Chen (1280–1350) always added this inscription as a footnote to his own work. "

To draw with a brush and ink on a soft rag paper is one of the most sensuous and expressive techniques available to the artist. One has only to explore the rich tradition of Chinese and Japanese brush drawings to appreciate the full potential of the medium. The landscape brush drawings of Hiroshige (1797–1858), for example, clearly influenced the work of the Impressionists.

The quality of a line drawn with a brush bears the imprint of the shape of the brush and the texture of the hair itself. It is important, therefore, to use good quality brushes. Any brush which does not hold its shape when wet is useless. The best sable brushes retain their shape in such a way that the natural curve of the hair forms the flexible rounded tip. Brushes made from synthetic hair, however, have been greatly improved in quality and are less expensive than sable brushes. Chinese brushes are also generally less expensive and produce a beautiful calligraphic line.

The action of drawing with a brush demands a degree of swiftness in order to keep the essential character of the brushstroke. It is therefore worth considering spending some time on preliminary mark-making exercises. Try holding the brush in different ways and use different sizes and shapes of brush, until you feel sufficiently confident to begin working directly from observation. The best brush drawings are done without any underdrawing with pen or pencil. The more dilute the ink or watercolour that is loaded onto the brush, the softer and paler the line will be. A brush that is almost dry produces an irregular broken line which is enhanced by using rough-textured watercolour paper. Try drawing contours with Indian ink and, when dry, overlaying washes of watercolour. Chinese ink is particularly good for producing gradated washes and for intense blacks.

An exercise using fine sable and broader mop brushes. Notice how the character of the stroke is determined by the shape of the brush.

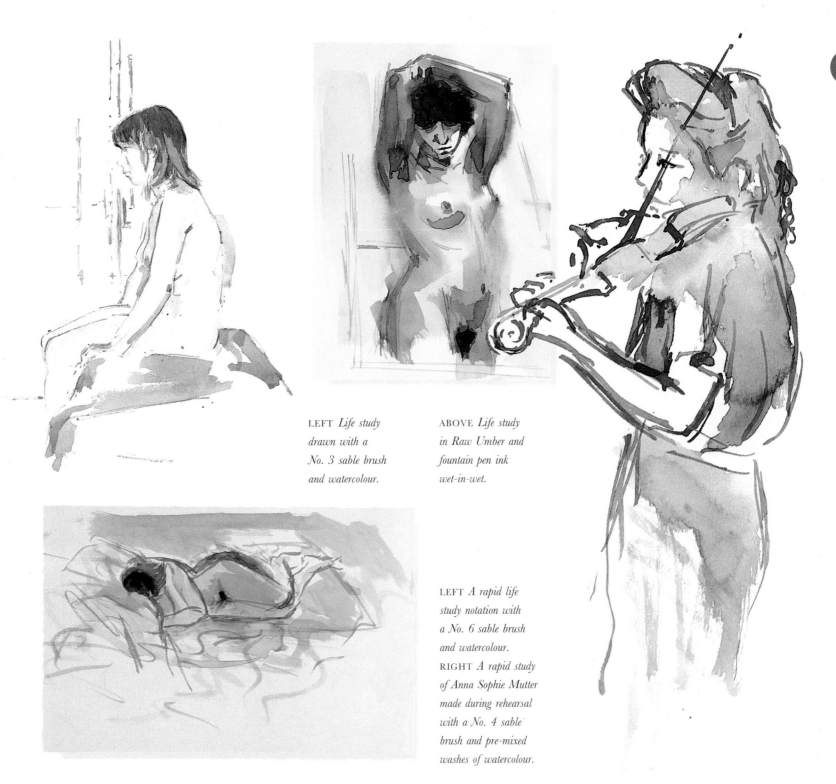

LEFT *Life study
drawn with a
No. 3 sable brush
and watercolour.*

ABOVE *Life study
in Raw Umber and
fountain pen ink
wet-in-wet.*

LEFT *A rapid life
study notation with
a No. 6 sable brush
and watercolour.*
RIGHT *A rapid study
of Anna Sophie Mutter
made during rehearsal
with a No. 4 sable
brush and pre-mixed
washes of watercolour.*

Paper

The paper you work on can contribute to the success or failure of a drawing. The strongly atmospheric conté drawings produced by Seurat (1859–1891), for instance, are enhanced by the texture of the 'laid' paper he used.

One can sometimes feel inhibited by working on expensive paper. It is not always necessary to use expensive handmade or mouldmade papers. When drawing in pencil or charcoal, any machine-made cartridge paper will be perfectly adequate.

There are three main paper surfaces H.P., NOT and ROUGH. H.P. (hot-pressed) is the smoothest and well suited to all kinds of graphite pencil, pen and brush drawing. When drawing in pencil, however, I prefer a NOT surface, which has a slight 'tooth'. A paper such as Saunders Waterford, for instance, is made from 100% cotton fibre which is sized internally for greater strength. As a result, the surface can withstand multiple erasions when using pencil or charcoal.

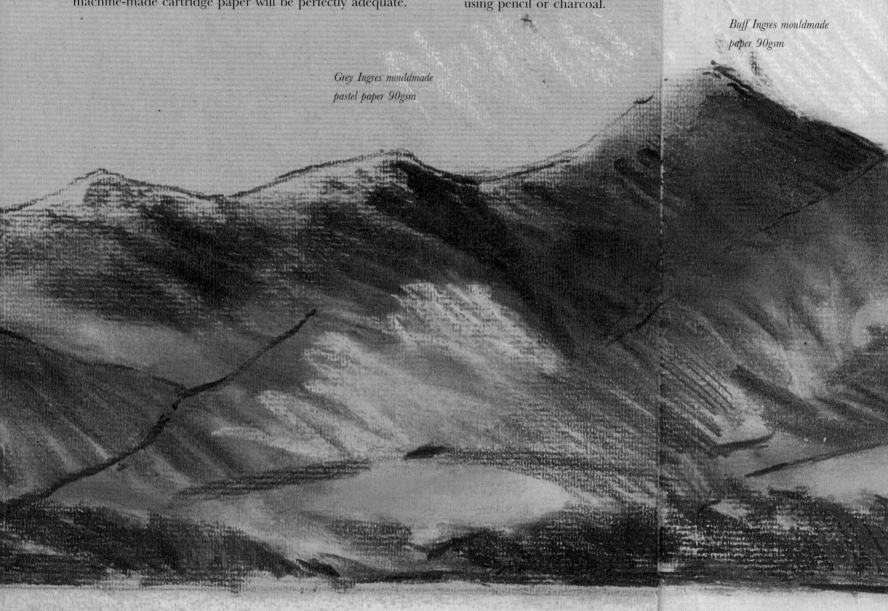

Buff Ingres mouldmade paper 90gsm

Grey Ingres mouldmade pastel paper 90gsm

ROUGH surface papers take on the texture of the rough paper-making felt. They are most suited to pastel drawing and broad-brush drawings. For charcoal drawing, my own preference would be either a Japanese paper such as HOSHO or one of the Indian Mulberry papers. Most handmade and mouldmade papers are manufactured in different weights and sizes. The weight is calculated in pounds (lb) per ream (500 sheets) or grammes per square metre (gsm). For most drawing purposes, a paper weight

of 185gsm/90lb is ideal. Try to ensure that the paper you buy is acid-free to avoid discolouration at a later stage.

In the end, your choice of paper will no doubt be influenced by your own needs. Most paper merchants produce sample books which will enable you to test the suitability for your own requirements. Degas produced many of his best pastel drawings on tracing paper because his work method (tracing one drawing over another) demanded a transparent paper.

Cream cartridge 96gsm

Acid-free white
cartridge 96gsm

Bockingford cylinder
mouldmade watercolour
paper 425gsm

'Crisbrook' Barcham
Green hand-made paper
unsized 535gsm

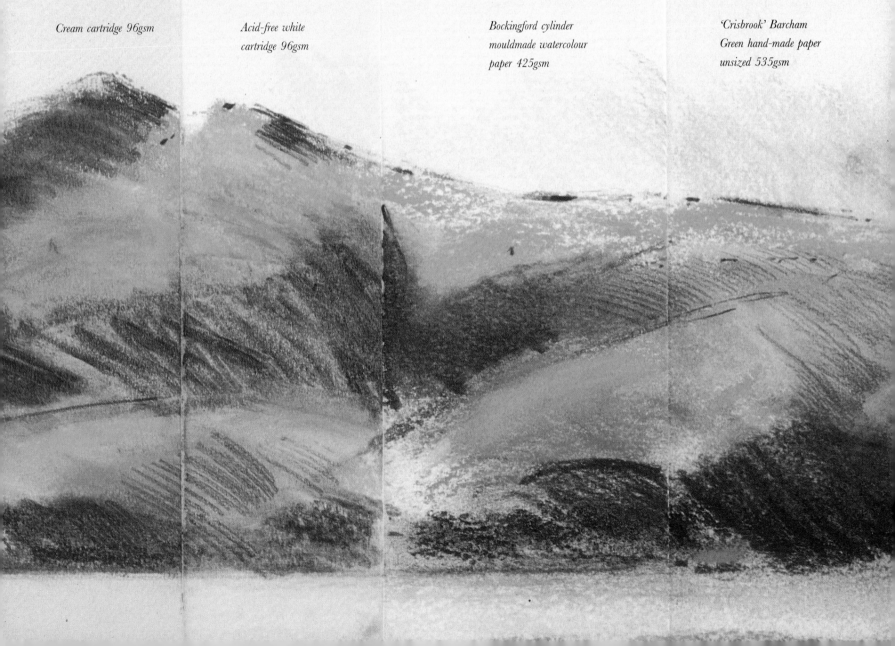

Erasing and Fixing

It is important to use an eraser of good quality which will eliminate unwanted lines and marks without damaging the surface of the paper.

For charcoal drawings and pastels, a kneadable putty rubber can be shaped with the fingers to lift out fine detail. Charcoal drawings can also be erased effectively with fresh bread which has been kneaded slightly.

The wedge-shaped soft pencil rubber and some plastic erasers are sufficiently pliable for most purposes. A soft gum eraser is the least likely to cause damage to the surface of the paper.

FIXATIVE

All drawings produced with graphite pencils, charcoal, conté and chalk pastels require fixing. Fixative liquid is applied by means of an atomised spray held approximately 30cm/12in from the drawing. For the purpose of fixing, the drawing should be laid on a flat surface and the spray moved back and forth to provide even coverage. Additionally, the back of the paper can also be sprayed to ensure complete saturation and protection. Always use the spray in a well-ventilated room, or use a face mask. For charcoal and graphite pencil drawings, skimmed milk makes a cheap and effective alternative, particularly useful if you are allergic to fixative spray. On graphite pencil work, simply paint the milk on with a brush. On charcoal drawings, use a diffuser spray (available in art supply shops). Put the milk in a jar and insert the diffuser tube in the liquid. Using the L-shaped diffuser mouthpiece, suck the milk up through the tube and then blow to spray it over the drawing.

There are a number of recipes for fixative, but most are based on a combination of shellac, resin and alcohol. Pastels should be fixed in stages to avoid neutralising the brilliance of the colour.

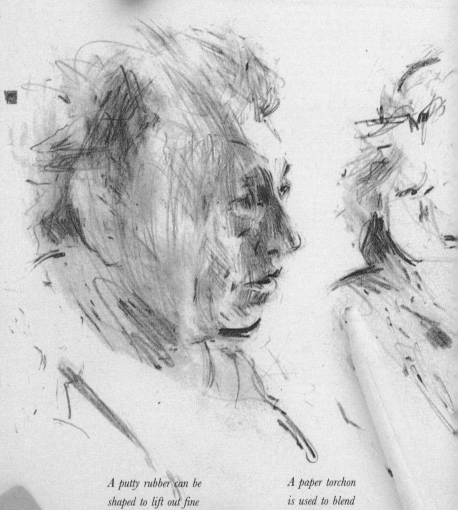

A diffuser spray can be used with standard fixative or skimmed milk.

Erasers are just as useful as pencils. They can make a positive contribution to a drawing. By taking out or lightening areas of tone, form can be altered or re-stated.

A chunky soft rubber is useful for general erasing.

A putty rubber can be shaped to lift out fine detail.

A paper torchon is used to blend and smudge.

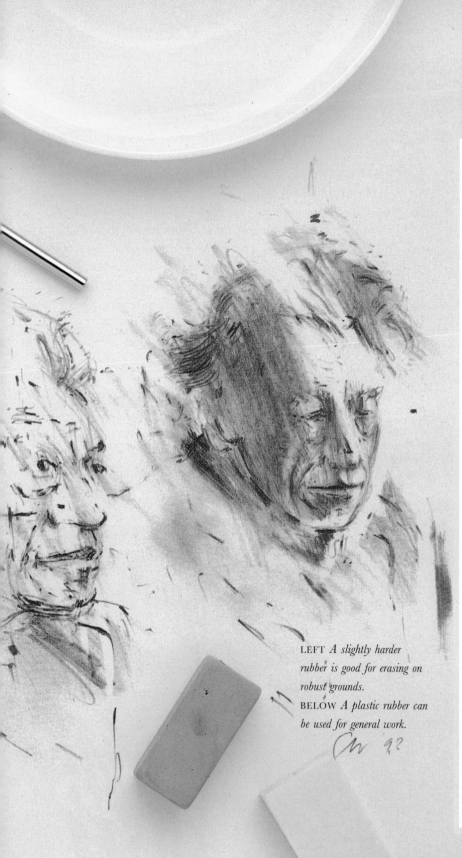

LEFT *A slightly harder rubber is good for erasing on robust grounds.*
BELOW *A plastic rubber can be used for general work.*

OTHER USEFUL EQUIPMENT

STOOLS AND CHAIRS

An investment in a folding stool or tubular steel chair is one I feel sure you will never regret. My own Maclaren 'Gadabout' chair has provided me with great comfort in various difficult locations from the Swiss Alps to the hill-towns of Italy.

The smallest and lightest stool generally available in most countries is the aluminium and canvas folding stool that is favoured by fishermen. This type of stool does not provide much back support however, and is rather too low on the ground. The three-legged French stools are well made, of good quality and easy to carry. The shooting-stick type of folding seat provides some support but is not much use for prolonged periods of concentrated drawing.

HARDWARE

A good pocket-knife, such as the Swiss Army knife, is an essential item of equipment. There are also a number of knives with retractable 'snap-off' blades which are equally useful.

Fold-back spring clips are practical when working outside to keep paper in place when there is a wind. A good light-weight shoulderbag, preferably made from waterproof material, will enable you to carry all your equipment when working outdoors.

Mark Making

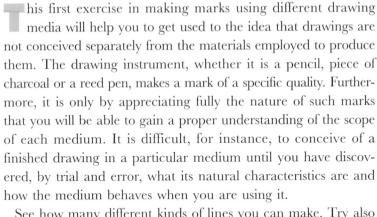

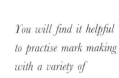

This first exercise in making marks using different drawing media will help you to get used to the idea that drawings are not conceived separately from the materials employed to produce them. The drawing instrument, whether it is a pencil, piece of charcoal or a reed pen, makes a mark of a specific quality. Furthermore, it is only by appreciating fully the nature of such marks that you will be able to gain a proper understanding of the scope of each medium. It is difficult, for instance, to conceive of a finished drawing in a particular medium until you have discovered, by trial and error, what its natural characteristics are and how the medium behaves when you are using it.

See how many different kinds of lines you can make. Try also to make stippling textures, spirals, zig-zags, circles and squares. Produce as many trial sheets as necessary until you feel that you are handling each medium with confidence and fluency.

You will find it helpful to practise mark making with a variety of drawing media, such as soft and hard graphite pencils, charcoal, compressed charcoal, pen and ink, brush and ink and spatter techniques.

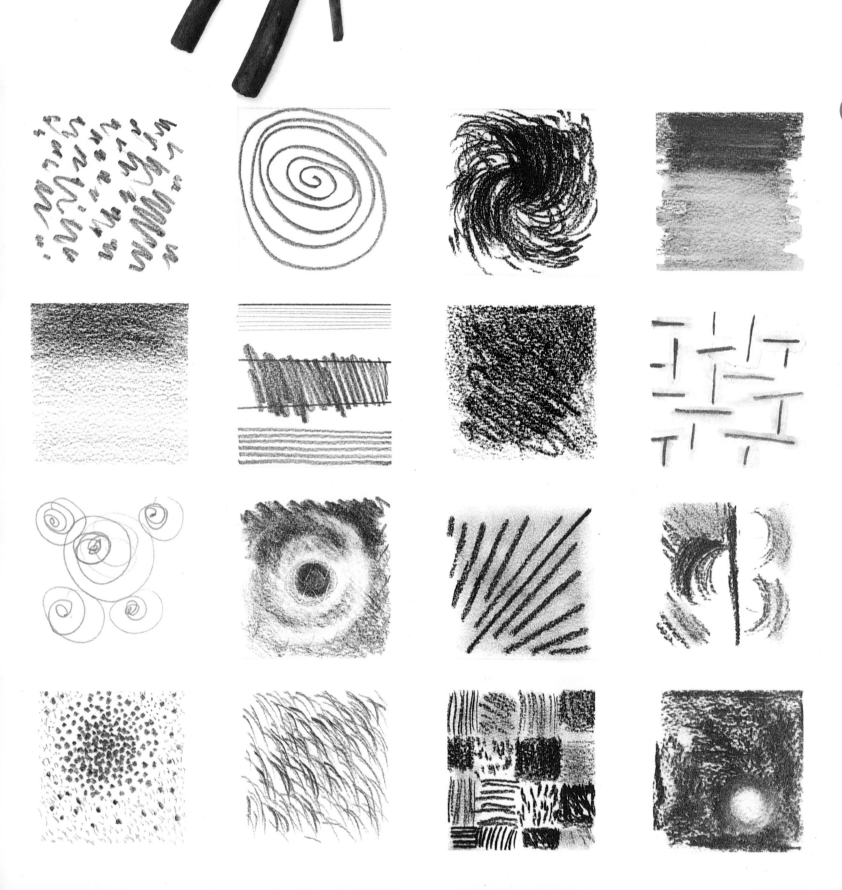

Tone

28

*The contrasts and connections of tones – there you have the secret
of drawing and modelling* – Paul Cézanne (1839–1906)

Cézanne observed that everything in nature is based on the
sphere, the cone and the cylinder, and he believed that if
one could only draw these simple forms correctly, it would be
possible to attempt more complex subjects.

A white teacup placed on the table before me as I write is a
cylindrical form which I could draw in line, for instance, but to
express the form of the cup, I would need to use tone. By tone,
we refer to the gradations of lightness to darkness which can be
seen in any solid object which reflects light. In drawings, we use
tones to create the illusion of depth and three dimensions. We
use tone to describe the anatomy of the human figure and, in
landscape, to suggest atmosphere and distance.

Tone can also be used to describe colour. If you were wearing
a pink T-shirt with blue jeans, for example, I would notice that,
apart from the difference in colour, the T-shirt is lighter in tone
than the jeans. Tonal values are also dependent on local colour
(the actual colour of the object). A dark object in light may actu-
ally be lighter tonally than the shadow on a light object. The
local tone of an oak tree, for example, might be dark brown, but
if strong sunlight were to illuminate part of the trunk, it would
appear much lighter in tone (on that part of the trunk) than on
the rest. This may sound obvious, but because we often expect
a particular object to be darker or lighter in tone, we sometimes
fail to observe exactly what is happening when an object is seen
under certain conditions of light.

The texture of an object can affect its tonal value; generally,
the heavier the texture, the darker the tone.

It is, of course, impossible to reproduce all the subtleties of tone
we see in nature, but even with a 2B graphite pencil, you would
be able to translate what you see in terms of transitional tones
from pale grey to near black.

The following exercises should test your ability to control tone
in basic terms. In the Project Section of the book you will see
how three artists confront exactly the same problems.

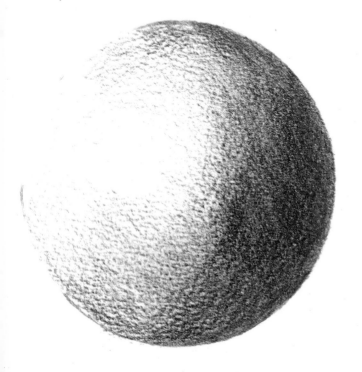

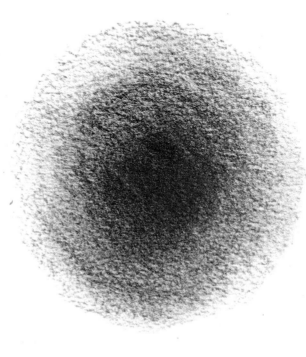

*Tone expresses form.
In this exercise, light
and shade follow the
form of the sphere on
the far left. The circular
area of tone increasing
in the centre (left)
creates a different form.*

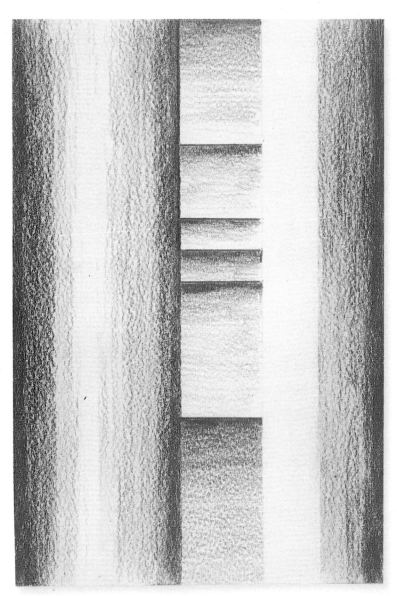

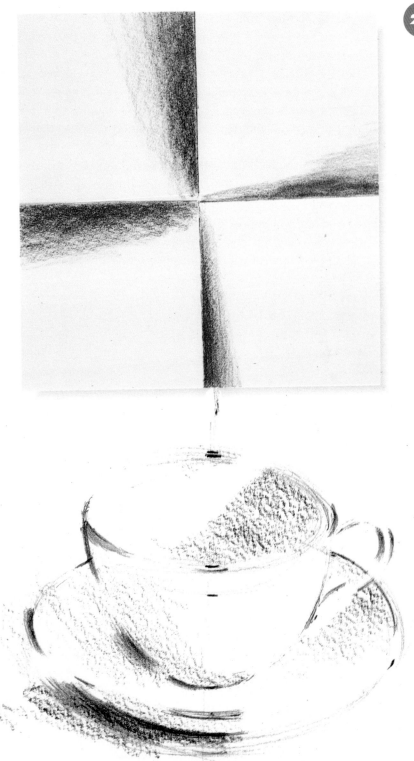

ABOVE *In this exercise in 6B pencil, variations in tone from light to dark turn lines into edges with a three-dimensional appearance.*

ABOVE RIGHT *Tone drawn with a 6B pencil to follow the folds in a sheet of paper.*

RIGHT *Tonal rendering of a teacup and saucer.*

Line and Tone

One of the most difficult problems you must confront when learning to draw is how to use line and tone together. When I first attended life-drawing classes, for example, I was expected to draw the contours of the figure with a needle-sharp pencil and then fill in the tones as a completely separate action. The resulting drawings were always artificial and contrived. It was some time before I found the confidence to fuse line and tone together as a single entity.

The balance between the weight of line and tone needs careful consideration. If the tonal strength is too intense, the value of the line will be lost. If, on the other hand, the tone is under-stated, the line will appear too dominant. In order to avoid this false division between line and tone, begin by working with a soft line – a 3B pencil will do. Make sure that the point of the

pencil is round and blunt. Let the tonal quality develop from the softness of the line itself as you begin to construct your drawing. Indicate light and dark tones by keeping your lines in the same direction. Try to unify tones by checking the overall relationship between the pattern of light and dark areas.

Lithographic crayons produce a soft, grainy tone rather than a sharp line, and artists such as Pissarro (1830–1903) and Bonnard (1867–1947) produced some of their most sensitive drawings in this medium. If you are using charcoal, you can dust off surplus pigment with a soft cloth to produce more delicate tones. When drawing with pen and wash, use the brush as well as the pen for the linear aspects of the drawing. Lines drawn with non-water-proof inks will dissolve when a wash is laid over, producing a fluid, irregular line.

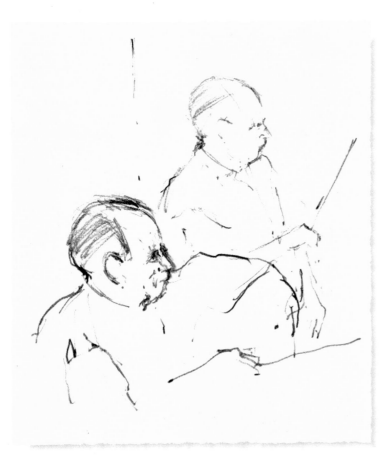

LEFT *Study of the conductor Sacher at rehearsal using 3B pencil on cartridge.*
RIGHT *Portrait drawn in 3B pencil on Bockingford paper*

RIGHT *In this life study in 4B pencil, lines are heavily impressed into the soft handmade toned paper.*
FAR RIGHT *Costume life-study. The wide range of tone in this drawing is produced with a 6B pencil on toned handmade paper.*
BELOW *Sketchbook life-study using a 3B pencil and an added wash of Burnt Umber.*

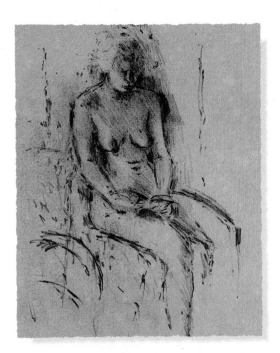

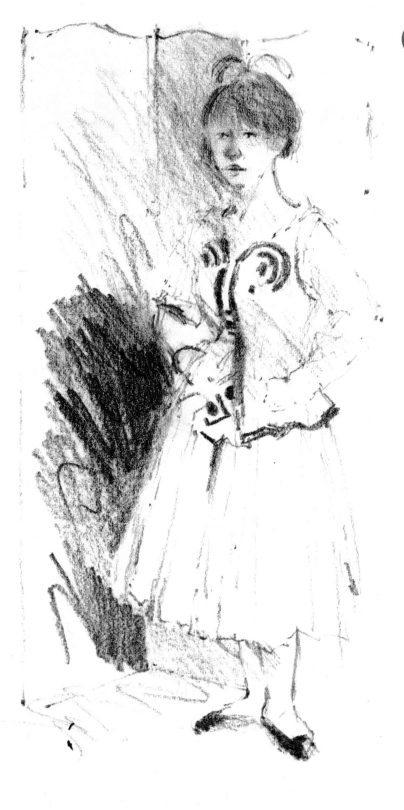

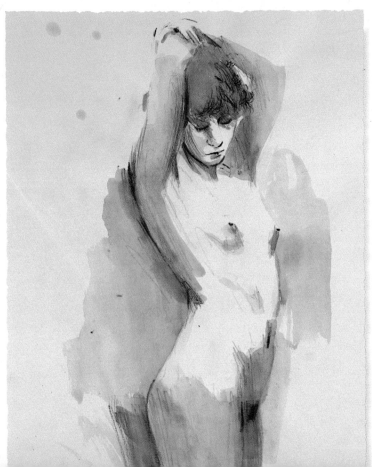

Positive and Negative Shapes

When we draw one shape, we are unconsciously creating another. The familiarity of the objects we choose to draw often prevents us from being aware of the relationship between positive and negative elements in our drawing. When looking at a still-life drawing by Cézanne, for instance, it becomes evident that the artist was sensitive to all the corresponding shapes he was creating. All the concave and convex arcs relate to one another, interlocking with the surface of the paper itself. Cézanne's art was the art of relationships, and that meant that the spaces between and around the objects and people he drew were as important to him as the objects themselves. Even drawings which appear understated or half-finished have a completeness which one rarely finds in the work of other artists.

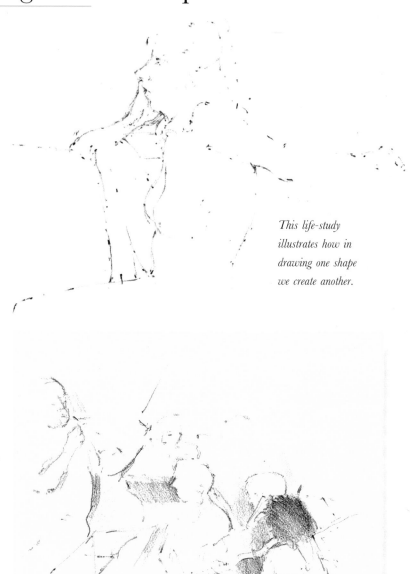

This life-study illustrates how in drawing one shape we create another.

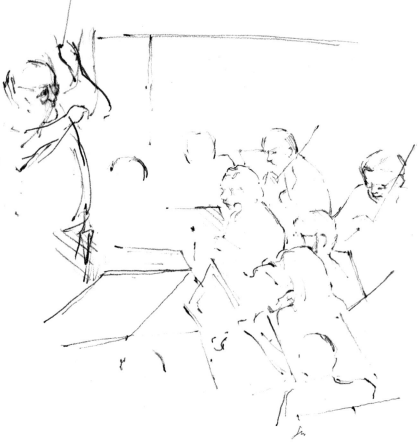

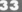

OPPOSITE, BELOW LEFT *Successive studies of the conductor Penderecki made as rapid notations during rehearsals. The figures are linked together by negative and positive shapes.* THIS PAGE *The understated drawings of these seated figures give equal consideration to positive and negative shapes.*

As an exercise in exploring shape, try setting up a still life, or get someone to pose for you sitting on a chair. Concentrate on the spaces and shapes between things. Draw selectively, investigating the purely abstract values of related positive and negative shapes. In approaching drawing in this way, you are much more likely to uncover aspects of your subject that would have gone unnoticed when drawing in your usual way.

Coloured Grounds

34 **W**orking on a coloured ground can add an extra dimension to your drawing. Renaissance artists often used a blue-grey or red-ochre paper to extend the tonal range of their work. By combining black, sanguine and white chalks on coloured paper, they developed the technique knows as *chiaroscuro* (the Italian term for light and dark).

I always associate drawing on a coloured ground with the drawings of Degas. He would sometimes prepare his own painted or stained grounds on paper – perhaps a rich pink or acid green – which contrasted beautifully with the brush drawings in sepia or bistre paint. You can buy coloured papers, such as Ingres, and work directly with charcoal, pastel or brush. Alternatively, you could try diluting oil or acrylic paints and stain your own white paper using a soft muslin rag.

Generally speaking, you will find that pencil drawings work best on very pale tints, while broader drawing techniques, such as pastel and charcoal, demand stronger background colour.

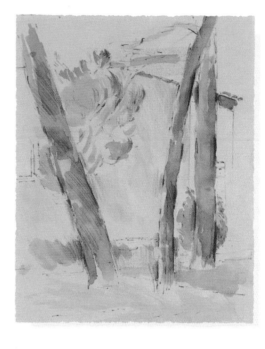

BELOW LEFT *A drawing made from a set pose using pencil, gouache and watercolour on toned paper.*
LEFT *A pencil and watercolour park scene on toned sketchbook paper.*
BELOW *Pencil drawing on paper coated with colour-stained gesso.*
RIGHT *A drawing of a street scene in gouache and chalk pastels on a sheet of unsized paper stained with diluted gouache.*

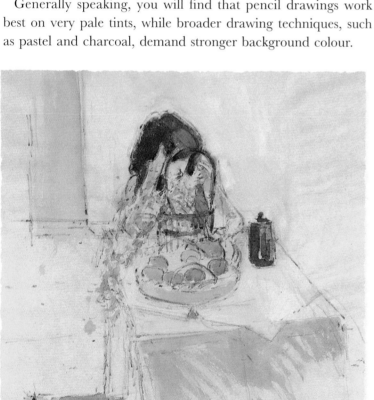

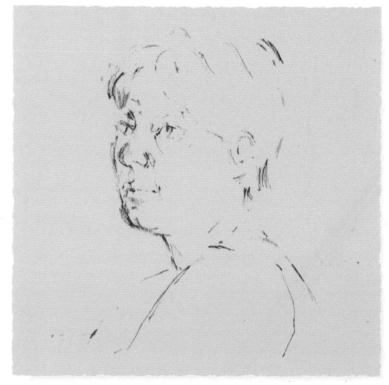

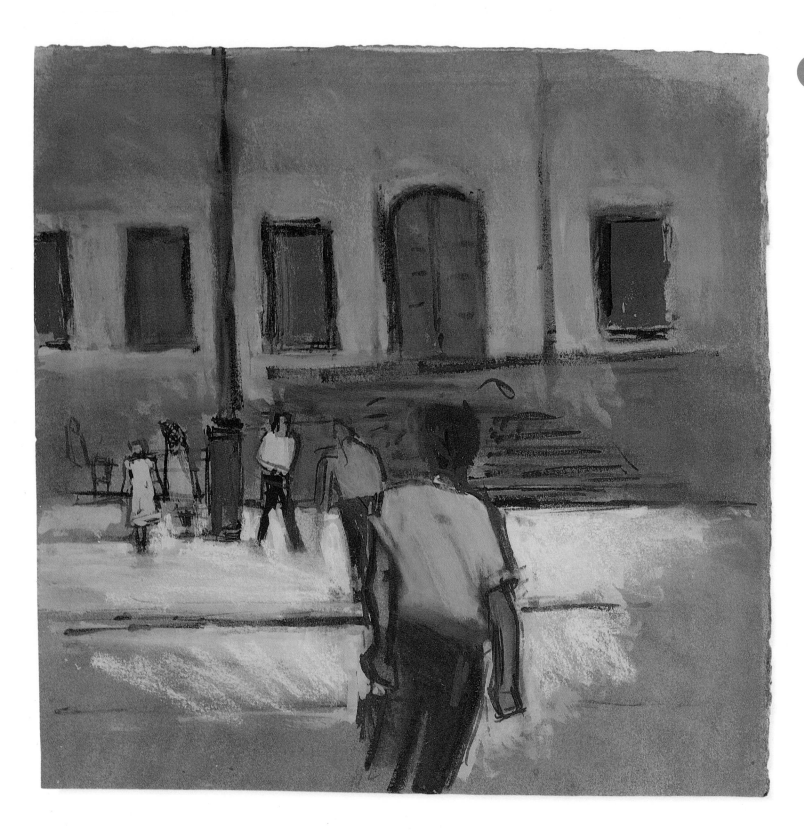

Drawing from Observation

> "
> *Two elements are needed to form a truth – a fact and an abstraction –*
> Rémy de Gourmont (1858–1915)
> "

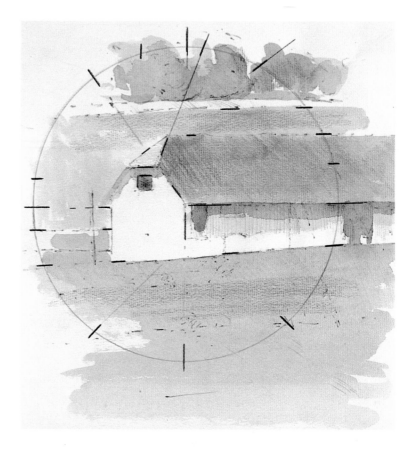

Because the reproduction or exact copy of nature is an impossible pursuit, we tend to abstract what we see. The artist never draws things as they are but as he or she sees them. And what we see, we commit to memory and try to register the main elements on paper with a pencil or some other drawing instrument. Drawing is the most direct, the most spontaneous medium available to the artist. The pencil becomes an extension of the hand through which the impulses of your sensory experience are translated into marks which symbolise what you have observed.

The artist Walter Richard Sickert (1860–1942) once gave what I believe to be the best description of the process of drawing from observation, and I feel it would be helpful to quote it in full:

All lines in nature, if you come to reflect on it, are located somewhere in radiants, with the 360° of four right angles. All straight lines absolutely, and all curves, can be considered as tangents to such lines. In other words, there is no line in nature which does not go in the direction of one of the little ticks that mark the minutes on the face of a watch. Given the limits of exactness needed for aesthetic purposes, if you could put on paper by sight the place, that is to say the minute of every line you see, you could draw.

You can test the truth of this statement for yourself by looking out of the window (it doesn't matter whether you live in town or country). You will see how the specific angles of various elements conform to the idea of the minute marks on a clock.

Try to make a drawing simply by marking some of the main angles you can see – perhaps the acute angle of a rooftop, the upright of a telegraph pole, the slope of the land and so on. Do not worry at this stage about producing a finished drawing: think of what you are doing purely as an exercise in observation.

Ruskin once said that if you want to draw, you must forget what you know and only look. It is difficult to do this in practice, but when you are drawing from observation you are trying to uncover things which might normally escape your attention. You will want to discover, through drawing, how natural and man-made forms are linked together, how one form overlaps another on different planes and how things change their appearance in different conditions of light.

If you are persistent in drawing from observation, you will eventually discover what all great artists know – that everything has its own shape, that nature is a harmony of opposites and that all forms are relative to one another.

Try to concentrate on seeing, rather than on 'self-expression'. The line drawn by the artist will, of necessity, bear the imprint of his or her emotional state. The gesture made by an impatient person will be different to the gesture made by someone who is by nature placid, gentle or contemplative.

OPPOSITE *The outline of a clock superimposed on a drawing of a barn illustrates Sickert's ideas about radiants and linked angles.*

TOP RIGHT *A study from direct observation of Zamora cathedral, Spain. The photograph was taken at the same time from the same viewpoint. Notice how extraneous details have been left out in the drawing.*

MIDDLE RIGHT *In this distant view of Segovia, Spain, the artist is seemingly able to project himself forward to focus on detail which seems lost in a photograph taken from the same viewpoint.*

BOTTOM RIGHT *A rapid sketchbook notation of a country church in Spain which evokes the atmosphere of the place more directly than the photograph.*

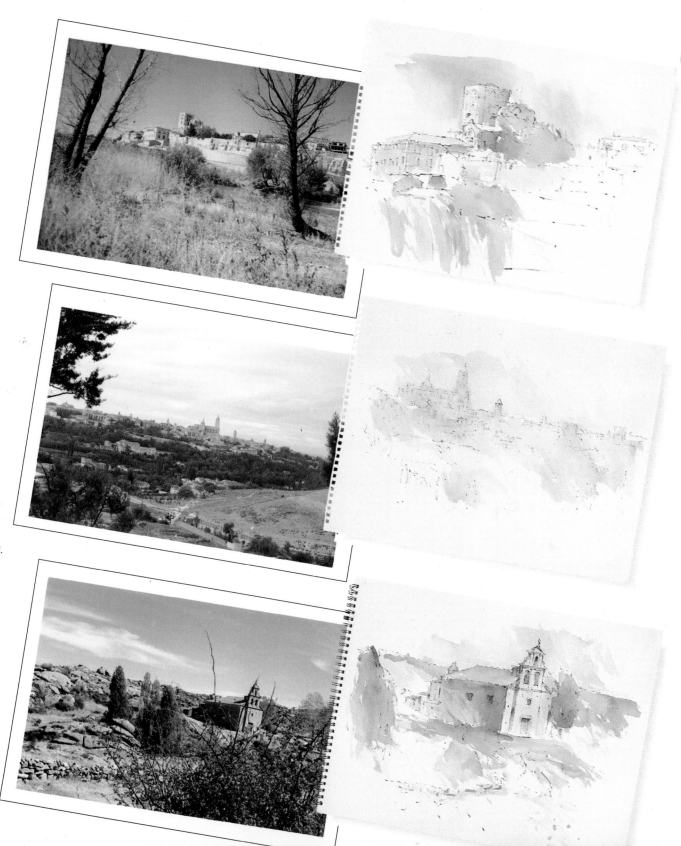

Measured Drawing

LEFT *Portrait. A drawing which bears the imprint of carefully judged intervals.*

BELOW *Life study. Notice how background and adjacent structures have been used as a means of checking the proportion of the figure.*

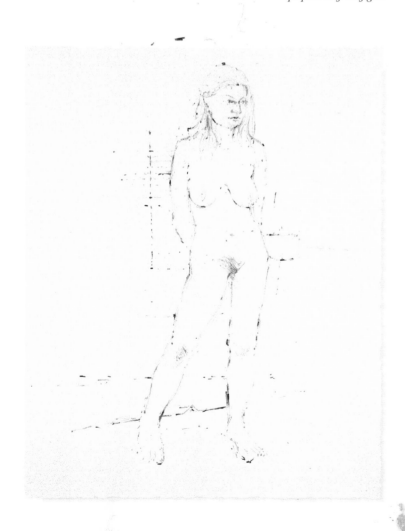

The marks that an artist makes when he or she is constantly searching for probity are an intrinsic part of the drawing. In Michelangelo's crucifixion drawings, for example, it is the multiple contours which reveal the artist's acute sensitivity to the subject. When beginning a drawing, do not allow the problem of measurement to inhibit or distract you.

When drawing from observation, no system of measurement is strictly accurate – a reasonable probability is the only certainty. According to Heisenberg's Uncertainty Principle, it is impossible to determine simultaneously, with any certainty, the position and the momentum of a particle: the more accurately the investigator determines one, the less accurately he or she can know the other.

Some artists adopt a system of measurement and continue to use it all their working lives. Others simply use their sense of visual judgement intuitively, and make continual corrections as the drawing progresses.

STANDARD MEASUREMENT

Imagine you are drawing a standing figure, and you want to determine the number of head-lengths that can be fitted into the total length of the figure. Hold your pencil vertically with your arm fully extended between one eye (the other closed) and the figure. Mark off between the tip of your thumb-nail and the top of the pencil, the length of the head. Then, lower your arm with the fixed measurement to see how many times that same distance will go into the total length of the figure. If, for example, you discover that the length of the figure is equal to seven and a quarter head-lengths, you can then register the distance with nodal marks on your paper. You will then be able to work out other proportions in the same way.

There are a number of devices you can use to make it easier to assess distance and proportion. Try, for instance, taping coloured drinking-straws to the model at main intersections of the body or make marks with red grease-paint.

When I am drawing a life model, I use surrounding furniture and fixtures as a means of cross-checking the proportions of the figure. The length of an arm or leg can be checked against adjacent chairs, tables, fireplaces, skirting boards and so on.

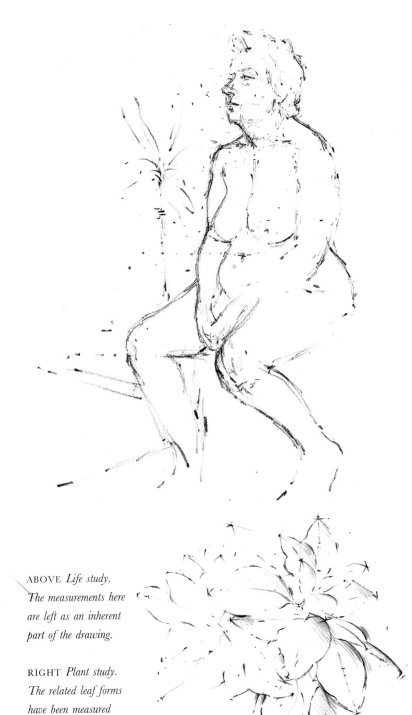

USING A GRID FOR STILL LIFE

Take a commonplace object, such as a milk jug or teapot, and place it against a previously-drawn background grid of 5cm/2in square. The size of the squares can be reduced or enlarged according to the size of the object. Draw a grid of the same number of squares on your drawing paper.

As you begin to draw the outline of the jug or teapot, note the position of the object against the squares of the background grid. Try to relate this position to the corresponding squares of the grid on your drawing paper.

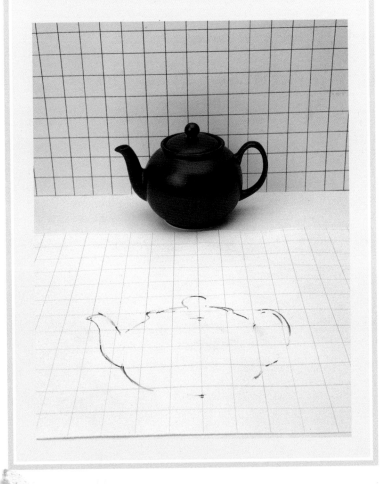

ABOVE *Life study. The measurements here are left as an inherent part of the drawing.*

RIGHT *Plant study. The related leaf forms have been measured by holding the pencil at arm's length and fixing the position on the paper.*

Scale

40

How do we convey a sense of scale in drawing? How, for instance, is it possible to make a church on a distant hillside look monumental and, at the same time, in scale to other elements in the drawing? Perspective would help, and we shall deal with that shortly, but more importantly we need to create a sense of space and distance between objects.

When we talk about scale, therefore, we are referring to the essential task of getting all the components of the drawing to appear to have the same size in relation to one another. Of course, there are times when the artist might choose to exaggerate such differences. Many artists manipulated scale to make a theatrical or allegorical point. Turner, for example, sometimes made castles larger than reality, and hills became mountains, in order to increase the dramatic effect in his paintings. It was part of Rembrandt's genius, however, that he was able to suggest scale convincingly even in a small landscape produced with a few pen lines.

Before you begin your drawing you will need to make certain decisions as to how large the principal elements are going to be. Supposing that you were to draw a landscape view and a farmer in your composition is standing right in the foreground so that you are only able to include the upper part of his body. You might then notice that a distant barn appears to be the same height as the farmer's left ear! In reality, of course, the barn might be four or five times the height of the farmer.

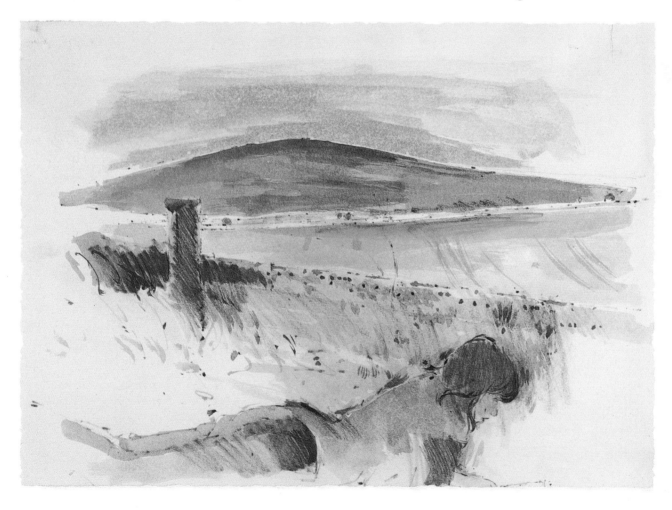

LEFT *In this landscape, the figure seen lying full length in the immediate foreground appears to be as long as the distant walls.*

RIGHT *In this sketchbook notation, the head of the figure appears to be the same height as the house in the middle-distance.*

FAR RIGHT *In the watercolour study the house appears to be half the height of the distant mountain.*

BOTTOM RIGHT *In this alpine scene, the lower part of the railings appears to trap the lake below.*

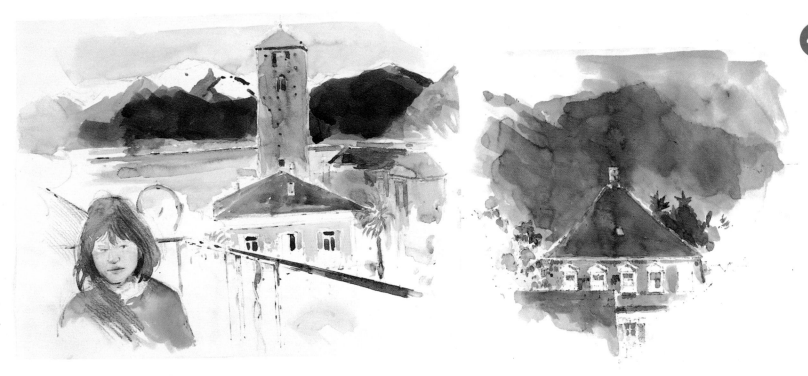

Most people tend to draw 'sight-size', that is, the size that you actually see things. If you were drawing a standing life model, for example, you would need to be approximately six metres/19 feet distant to see the whole figure. The corresponding drawing on your paper might only be 17cm/7in. high. How can you tell whether or not you are working 'sight-size'? If I am working in an A3 sketchbook (420 x 297mm/16.8 x 11.88in.) and want to draw my study window (about two metres by one-and-a-half metres/six feet by four feet), I would need to stand approximately four metres/13 feet away from it. Then if I were to hold my sketchbook up between my eye and the window, I would see that it would fit comfortably on to the page.

It is perfectly possible, of course, to produce drawings which are larger or smaller than 'sight-size'. It has been fashionable in some art schools for some time to produce drawings of mundane objects on an enormous scale on huge sheets of paper. The intention is to impress by the sheer scale of the work, but all that generally happens is that one becomes more acutely conscious of the basic inadequacies of the drawing itself.

Perspective

We see things in depth – that is, we see objects spaced at different intervals from each other and from where we are standing. When we talk about drawing 'in perspective', we are describing a means of creating the illusion of depth on the flat surface of the drawing paper or canvas.

If your eye is sufficiently well trained, it is perfectly possible to do this accurately, without any knowledge of the theories of perspective whatsoever. On the other hand, a basic knowledge of perspective will free you from needless and unproductive anxiety when you are tackling difficult subjects such as a street scene or an undulating landscape.

The whole idea of creating the illusion of three dimensions in drawing is attributed to the architect and sculptor Brunelleschi in the early 15th century (Brunelleschi's theories were described by Leon Battista Alberti in his treatise *Della Pittura*, written in 1436). Perspective is based on the assumption that all parallel lines going in any one direction appear to meet at a single point on the horizon known as the Vanishing Point.

The principles of perspective can be tested quite simply by tracing an outline of the objects that you can see through your window directly on to the surface of the window pane (using the kind of fibre-tip pen that adheres to slippery surfaces). When you have traced the outline, you will notice how everything appears to be deployed in depth, as the more distant things are, the smaller they become.

THE PICTURE PLANE

Another concept which helps to explain perspective is the picture-plane. This is an imaginary vertical plane which is set on the ground at the distance from the artist where the picture is intended to begin. The true size of any object can be found by projecting it forward on to the picture plane (see the diagram below).

All horizontal lines at 45° to the picture plane meet at a point on the horizon line which is the same distance from the vanishing point as the vanishing point is from the eye of the observer (see diagram on page 43).

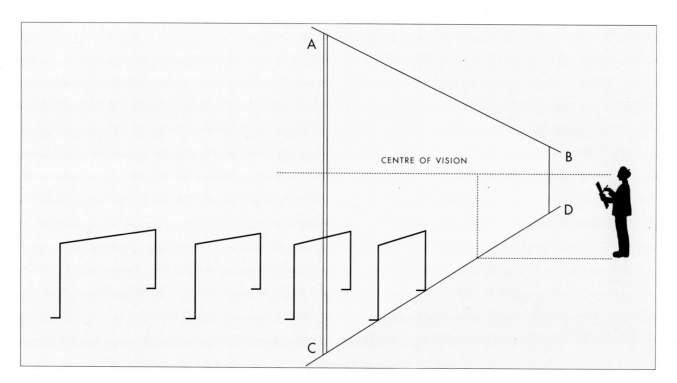

LEFT *The picture plane ABCD is an imaginary transparent vertical plane between artist and subject. The base of the picture plane is called the ground line and it is from this line that measurements are taken. There is a point on the horizon immediately in line with the eye which is the centre of vision.*

EYE-LEVEL

This is the term we use to describe the position of the eye in relation to the horizon. If, for example, you are standing on a flat surface and your eye is level with the top of a fence, then that is the eye-level. If you then move some distance from the fence and sit down your eye-level will, as a consequence, also shift to a lower level.

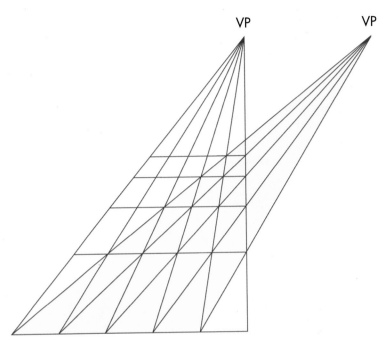

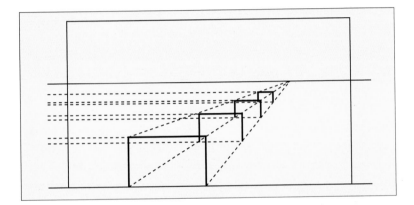

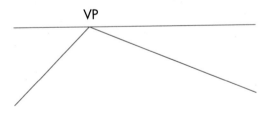

ABOVE *Objects of the same size appear to diminish in size as they get near to the horizontal line.*

LEFT *Lines which are parallel to each other converge at the vanishing point VP.*

ABOVE RIGHT *Each set of parallels has a separate vanishing point.*

THE VANISHING POINT

Having established your eye-level on the horizon line, you will find that all lines that are parallel to each other are drawn to the same point – the Vanishing Point. Lines which are parallel to the ground and above your eye-level are drawn down to the horizon eye-level. Conversely, parallel lines below the horizon are drawn upwards to the eye-level. Each set of parallels has a separate Vanishing Point. Objects of the same size will appear to diminish in size as they recede from us and the smaller they get, the nearer they will seem to be to the horizon line.

AERIAL PERSPECTIVE

As objects begin to recede from the spectator, there are observable changes in colour and tone. In landscape, particularly in northern Europe, the density of the atmosphere causes tones and colours to be more muted. Colours tend towards blue in proportion to their distance from the observer. One of the main concerns of the French Impressionists was to register such changes as they occurred when painting outdoors.

Composition

44 **A** musical score, a painting and a gourmet dish are all the products of someone consciously putting together something from related parts. In just the same way, a drawing or painting that is well composed is one whose parts have been skilfully brought into a satisfactory visual whole. In great classical paintings, all the constituent parts form a harmony which is pleasing to the eye.

If one considers, for example, the constituent parts of a landscape, one can usually break things down into a small number of interlocking shapes such as the sky, distant hills or mountains, perhaps a building in the middle-distance and grassland in the foreground. The degree to which each of these constituents occupies more or less of the surface area of the drawing or painting will depend very much on the artist's intentions. Constable (1776–1837), for instance, made drawings from nature in the low-lying landscape of East Anglia, where the sky predominates. In many of his drawings, therefore, one sees that the horizon is placed low in the composition, and the sky occupies perhaps two thirds of the drawing.

In the past, painters sometimes used to introduce elements such as a meandering river or a winding path as a visual device which would lead the eye of the spectator towards the most significant part of the composition.

Impressionism and, to some extent, photography displaced the classical notion of composition and conditioned us to accept a less formal, more casual arrangement in the way that drawings and paintings are composed. One advantage that the artist has over the photographer is that they can leave out any extraneous detail which might spoil the general balance of the composition.

When drawing a town or cityscape, for example, one might decide to leave out altogether a number of cars and other vehicles parked in the street. Alternatively, if it was precisely your intention to contrast the garish coloured shapes of the vehicles against the more subdued tones of the surrounding architecture, then you would keep them in your composition.

If you have difficulty in seeing compositional possibilities when drawing from observation, try using a viewfinder (a rectangle or square frame cut from a sheet of black card). Move it about before

the scene in front of you until it frames the kind of composition you are looking for.

Whatever subject you decide to draw, whether it be a landscape, life model, portrait or still life, you should consider beforehand how the composition might work. Begin by asking yourself a number of questions. Will the house you have seen on a hillside look more dramatic if drawn from a greater distance? Would the pose of the life model look better by working from a higher vantage point, thus changing the eye-level? Will the features of the model who is posing for a portrait work best against a light or dark background? Should you allow more space between the objects you have selected for your still life? All of these considerations might help to improve your composition.

THE GOLDEN SECTION

Also known as the Golden Mean, this is the name given to a means of dividing space harmoniously, and has been known since the time of the Greek mathematician Euclid (300BC). The basic premiss is that the proportion of the smaller to the larger is the same as the larger to the whole. (See Golden Section rectangle diagram, right.) In practice, this works out as a proportion of 8:13 and is the underlying division of many great works of art.

OPPOSITE LEFT
As a basic exercise in composition, select three stones or pebbles of different shapes and sizes and arrange them according to your own sense of visual judgement within a rectangle.
ABOVE *Two transcriptive studies from the painting by Pieter de Hooch (1629–1684) 'The courtyard of a house in Delft', 73.5 x 60cm. A striking feature of this composition is the orange shutter on the left, opened at a window we do not see. Notice how all related elements are linked together.*

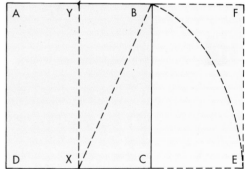

ABOVE *Underpinning the composition of most great drawings or paintings is a variant on the Golden Section rectangle. To help yourself understand the way this works, create a Golden Section rectangle on paper. Start with a square ABCD. Divide the square in half with line YX. Place a* compass point on X and, using B as a radius, describe an arc cutting the extension of line DC at E. Raise an upright from E to meet the extension of the line AB at F. The Golden Section rectangle is AFED. The line BC indicates the Golden Section division.*

Keeping a Sketchbook

46 **D**eciding what to draw and how to find subjects which reflect our own interests can be frustrating if we do not allow ourselves to be alert to a wide range of possibilities. If you can get into the habit of carrying a sketchbook around, the better prepared you will be to make drawings of things that unexpectedly beckon your attention.

It sometimes happens that you stumble across a subject which you feel you must respond to there and then, only to discover that you have left your sketchbook and drawing materials somewhere else! This kind of disappointment is compounded when, visiting the same place again, it has for one reason or another changed completely. Sketchbooks are useful for those occasions when you feel the need to draw on impulse. You can take risks when drawing in a sketchbook which you might feel more inhibited about if working on an expensive sheet of paper.

You might find it useful to keep several sketchbooks in varying sizes for different themes – museum studies, landscape, figure studies and so on, building up your own sources of reference. If you are travelling abroad, you might fill a number of sketchbooks as a kind of visual record of your journey. This is exactly what Turner did, producing on average 17 sketches a day when he travelled through France, Germany and over the Swiss Alps to Italy during his Grand Tour of Europe.

My own feeling is that a sketchbook should be used both for making shorthand visual notes and for more prolonged studies when working from direct observation. An artist's sketchbook will reveal his or her first impressions of things seen, and also record particular interests and obsessions.

*Sketchbooks are manu-
factured in a variety of
shapes and sizes. Paper
ranges from smooth,
inexpensive cartridge to
heavily textured surfaces.*

Sketchbooks are produced in many shapes
and sizes but all too often their dimensions
conform to accepted standards of measure-
ment. It is difficult, for instance, to find a
ready-made sketchbook that is square!

The 'A' series of sketchbooks range from the
smallest A5 (148 x 210mm / 5.83 x 8.27in) to the
largest A1 (594 x 841mm / 23.39 x 33.11in). The
quality of paper varies from inexpensive cartridge
paper to heavier mouldmade paper in H.P., NOT and
ROUGH surfaces. I generally use a sketchbook with a
wire spiral binding so that the pages can be folded
back easily for drawing.

If you have access to bookbinding facilities, you could
have your own selection of paper made up into a sketch-
book with the added advantage of having it made any
dimension – even square.

Figure Studies

48 When we start to draw, our expectations are often too high. Intent on producing the 'perfect drawing', we run into difficulty from the first lapse in concentration. Sometimes, it is better to settle for less in the hope of gaining ground. Figure drawing is probably the most challenging subject to confront any artist. The beginner, faced with a life pose of two hours or more, might feel a sense of trepidation bordering on panic!

Lack of confidence can be dealt with in a number of ways; beginning with a series of short poses which leave no time for second thoughts. By drawing more rapidly, you will tend to produce figure studies that are more resolute. In my experience, students doing figure drawing often position themselves too closely to the easel. Working thus, they shield themselves from the model and disrupt the process of hand and eye co-ordination.

To overcome this problem, try the following experiment. Into one end of a stick of bamboo (about one metre long and two centimetres in diameter) cut two slits so that you can insert a piece of charcoal which is slightly larger in diameter. Make sure that the charcoal is gripped tightly in the end of the stick and if

necessary bind it with thread. Now, stand well back from the easel, holding your bamboo stick rather like a fencing rapier, and begin to draw from the model. At first, you will find that this way of drawing is disconcerting, because you will have less control. However, you will have a much better view of the model and you will soon discover that, as a consequence, your drawing will be ruled by what you see, and not dictated by technique.

Short poses might be staggered in time limits from say, 30 minutes to 20, 15, 10 and 5 minutes, The sequence could, for instance, be a series of arrested movements from stooping and kneeling to stretching and standing.

Consider where the central axis lies in terms of weight and balance. By going after the structure first, the drawing can be made simpler. If time allows, you can give further consideration to the modelling of the form by introducing tone. The sense of solidity can also be expressed in terms of 'lost' and 'found' contours. When a line is broken it suggests light at the edge of the form; corresponding contours will be more intense in tone to emphasise the amplitude of the figure.

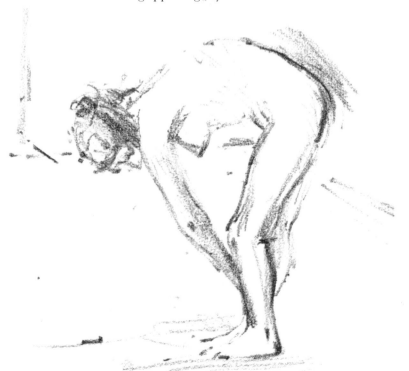

Drawing from quick poses is good practice for loosening up hand and eye co-ordination. The five- and ten-minute poses (LEFT and RIGHT respectively) only allow time for an instant response to the figure, giving more of an overview than a finished study.

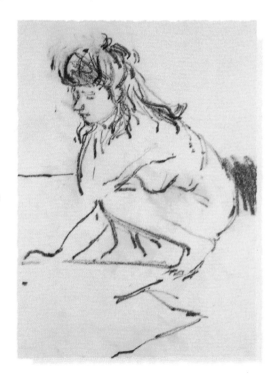

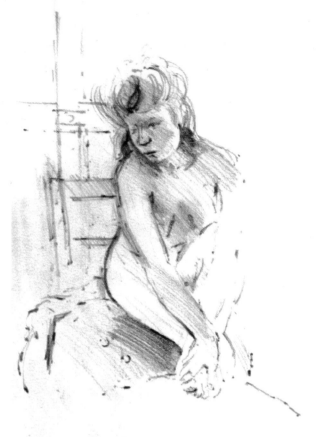

FAR RIGHT *A 15-minute pose allows time to register a response to the effects of strong light and shade and to explore tonal relationships.*

ABOVE AND RIGHT *Longer studies give scope for a more measured account of spatial relationships. The space around the model becomes more important.*

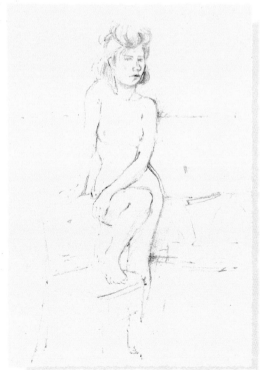

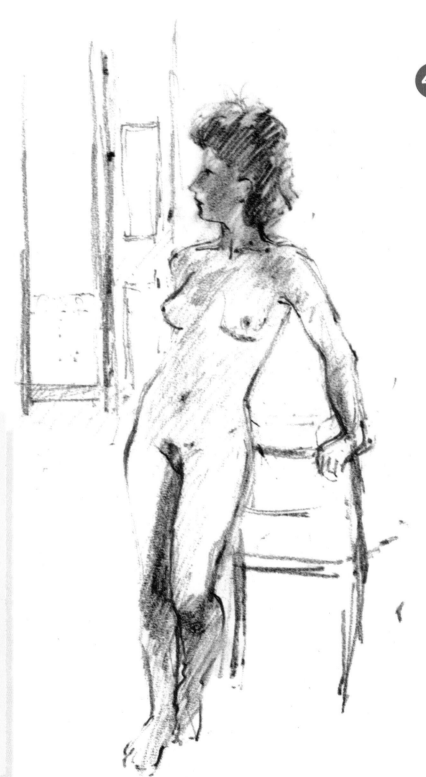

Landscape

50

The artist approaching a landscape subject for the first time will no doubt be overawed by the immensity of the view with which he or she is confronted. Landscape is indeterminate, allowing the eye to select freely and to group and compose various elements. Each of us is faced with the task of attempting to rediscover the landscape we inhabit through our own stream of consciousness. To do this, a series of senses are necessary. We need a sense of scale and proportion, rhythm and movement (nature is never still), a sense of the spatial immensity of landscape, of advancing and receding forms, of structure and of the organic nature of growth.

Landscape drawing is essentially, then, about the art of relationships. The artist sees everything in terms of his or her own emotional response to a place, regrouping all the various elements in view. There is a need to observe the particular disposition of buildings, rivers, trees, bridges, and so on, and be able to put them together in such a way that a kind of drama is released. By describing in his or her work the emotions attached to specific objects in the landscape, the artist is able to express something about the spirit of a place.

Places which are a source of inspiration to one artist may well alienate another; much depends on the kind of images an artist stores in his or her own mind. There is a temptation, for instance, to make drawings in well-tried locations which may have elicited fine work from those artists whom we admire and respect. The artist Paul Nash (1889–1946) felt that an artist usually works best

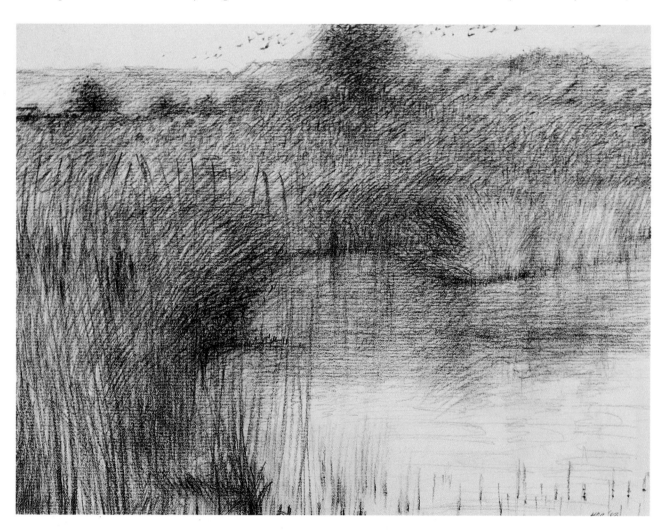

LEFT *The intricate pattern of reeds in this wetland scene demonstrates the artist's skill in seeking and translating the subject in a purely tonal way.*

OPPOSITE RIGHT *Notice how the artist has accentuated the structure of the rocks seen against background foliage in this study of a stone quarry in Scotland.*

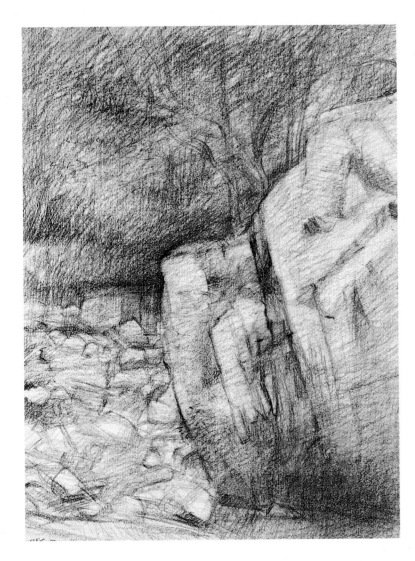

not truly understand. As the writer G. K. Chesterton once said, 'if you look at a thing nine hundred and ninety-nine times, you are perfectly safe; if you look at it for the thousandth time, you are in frightful danger of seeing it for the first time.'

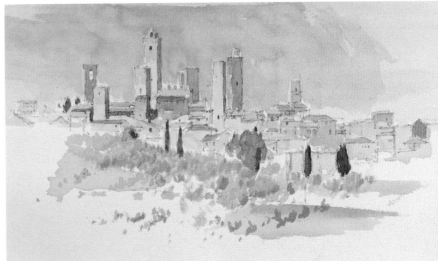

ABOVE *The distant towers and olive grove are seen in brilliant sunlight in this pencil and watercolour of San Gimignano, Italy. There is an interesting relationship between the predominantly horizontal landscape form and the strong verticality of the towers and cypress trees.*

LEFT *The suggestion of filtered light in this drawing of a garden scene is achieved by carefully controlled tones.*

in 'his own backyard', but that sometimes he or she had to travel around the world to discover that simple fact.

I usually look for landscape subjects where there is some kind of 'incident' where there is some feature which significantly transforms an otherwise tedious view. Begin with the places you know best. If, however, you find that your senses have become dulled by over-familiarity, plan a journey to somewhere you have not been before. It's a tall order, but you should try to look beyond the picturesque, to uncover those things that you see but you do

Growth and Form in Nature

52

In any garden the eye is caught into awareness at every turn; flowers, shrubs and plants of all kinds can present an endless variety of subject matter.

Van Gogh often used to draw and paint flower studies during the winter, or when the mistral prevented him from working outside. Begin by choosing a single specimen and look carefully at the structure: the way that the leaves and flowers are formed, the texture and precise shape of leaves, and so on. Notice how a kind of underlying geometry supports the free forms and consider the overall shape before trying to draw details such as the serrated edges of the leaves. Everything in your drawing needs to be organised in proportional relationship. Delacroix said that one should

'realise an image by a process analagous to the autonomy of nature'. This means that each and every specimen we draw is unique and to fully understand how one plant or flower is different from another. We need to observe with great care how interdependent all the shapes are in forming an organic whole.

You could apply the method of measured drawing described on page 38 by using the top of your pencil and thumb to measure a single leaf or flower as a unit to be set against everything else.

There are of course other natural forms, such as fossils, animal skulls or unusual stones, which are found at random. These can be brought back to the studio to draw individually, or can be collected together as part of a still-life group.

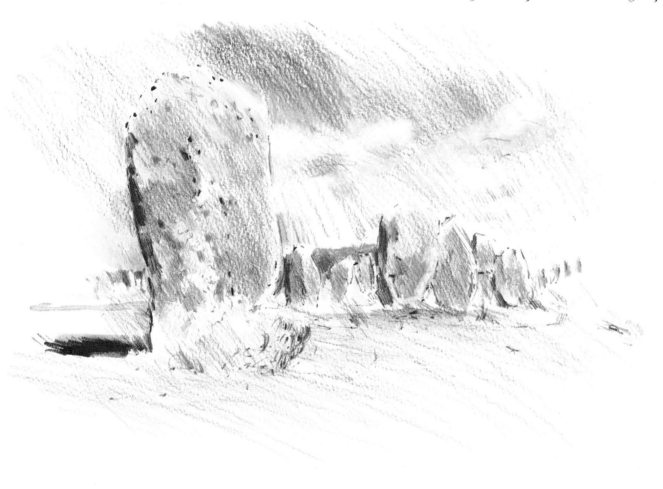

The standing stones at Carnac in France are naturally occurring stones arranged in a kind of monumental still life. This drawing was made in coloured pencils on Bockingford paper.

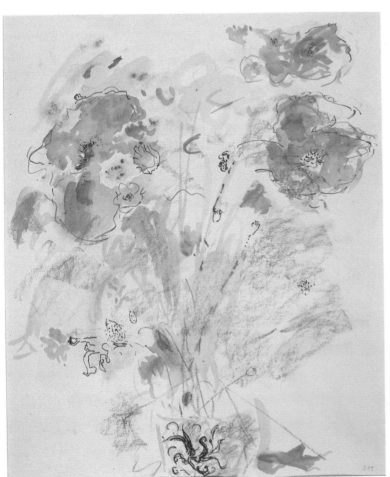

RIGHT *In this sketchbook study the complex rock strata has been rendered in graphite. Coloured pencils have also been used to make colour notes for future reference.*

ABOVE LEFT AND RIGHT *These exuberant flower studies combine pencil, pen and ink, chalk pastels, watercolour and coloured inks.*

Architecture

54 Our awareness of a particular building, seen either in isolation or in a town or city, is usually dependent on the quality of the light. The extravagant detail of a baroque cathedral might go almost unnoticed on a grey overcast day, but a humble farm cottage caught in a shaft of sunlight on a hillside can command our attention instantaneously. The season and time of day can, therefore, be particularly important. The whole mood and atmosphere of an architectural subject can change dramatically with the movement of the sun. A gaunt gothic cathedral might look most inspiring when silhouetted against the pale sun of a wintry afternoon. The white architecture of a Spanish or Greek town, on the other hand, might be best seen when strong sunlight produces sharp tonal contrasts.

Time is an important factor when planning to draw architecture. You can, of course, make a perfectly good rapid summary statement in a few minutes, but that would leave you with very little understanding of the values of proportion. I only began to understand the exquisite symmetry of Palladian architecture, for example, after I had spent a day trying to register the proportions of the Redentore church in Venice.

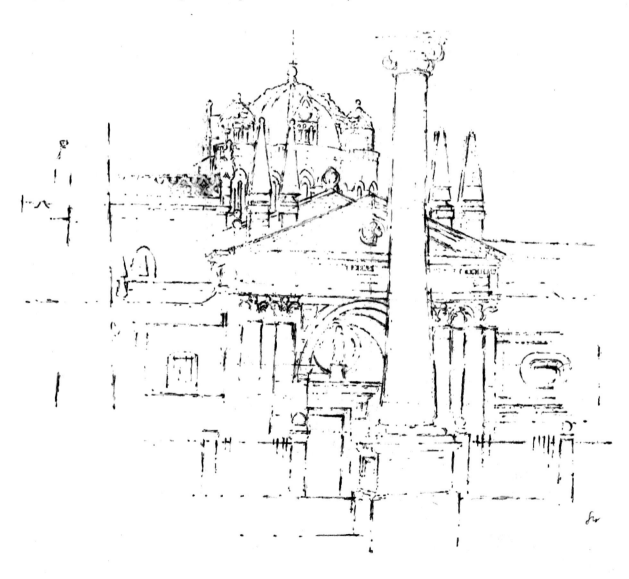

This drawing of Zamara Cathedral in Spain was produced from direct observation in about three hours.

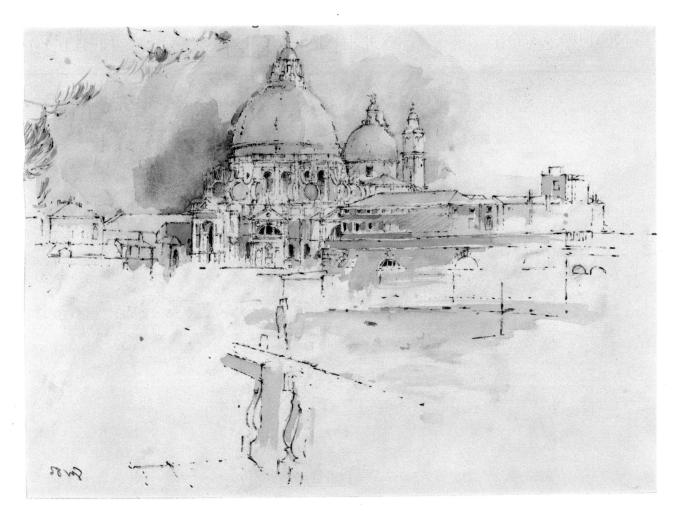

LEFT *Santa Maria Della Salute, Venice drawn in pencil and watercolour at midday. Watercolour is used sparingly leaving undrawn areas of white to suggest the intensity of light.*

BELOW *Alte Kirche, Fluelen, Switzerland. In this drawing the artist was mainly interested in seeing the church in relation to the structures of overhead power lines for the adjacent railway.*

Whatever style of building you are drawing, you should first make sure that it will fit on your pad or paper. This may sound obvious, but all too often in our haste to get started, we tend to overlook such fundamental calculations.

Once you have indicated external dimensions in your drawing, consider all the internal divisions between windows, doors, buttresses and so on. The width of the building might, for example, be determined by the way you judge visually the spaces between windows. Some artists prefer to make an initial drawing using a hard pencil, sorting out the main structural details before re-stating and developing the drawing with a softer pencil. You might try this if you are uncertain of your initial judgements.

Washes of watercolour, used sparingly, can add an extra dimension to the drawing by enhancing contrasts.

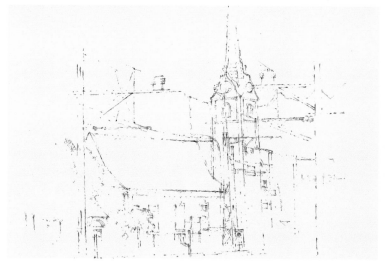

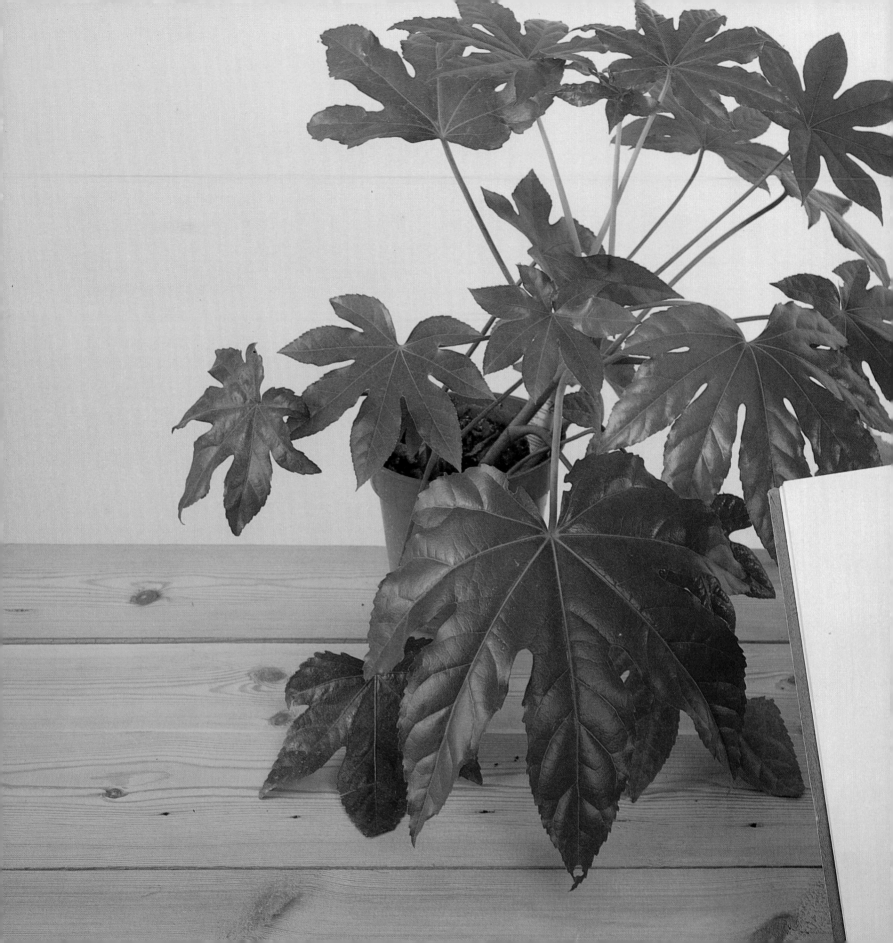

THE
PROJECTS

How the Projects Work

In the first part of this book we have explored a wide range of drawing techniques and looked at their application through a variety of exercises. Additionally, the problems of scale, measurement, perspective and composition have been introduced in a fundamental way. Once you have fully grasped the basic techniques of drawing, you are able to extend your ability to see and to comprehend what you see, by expanding your visual vocabulary.

In the Project Section which follows, the author and two other artists have worked simultaneously from the same sources of reference to produce very different interpretations of the same subject.

I believe that an artist should be judged by what he or she does with the subject, not by what the subjects are. It sometimes happens, however, that the subject itself will determine the technique used.

At the conclusion of each project, there is a critique which briefly summarises what I believe to be both the positive and negative aspects of each completed work. My hope is that in considering what we may have achieved – or lost – you will feel sufficiently encouraged to put this book to one side, and begin to produce drawings which reflect your own response to similar problems and subject matter.

Even if the drawings you produce as a result of studying this book do not match your expectations, remember that any attempt to produce a good drawing which fails still counts as a success! It's the trying that counts!

ALICE ENGLANDER has responded to each project by employing a different drawing medium according to what, in her view, the subject demands. She uses, for example, a lucid pen line and wash for the figures in a swimming pool but changes to softer tones of charcoal to express the atmospheric qualities of wintry trees emerging from mist.

As a successful illustrator of childrens' books, Alice Englander makes drawings that are distinguished by a sound grasp of form. This understanding enables her to deal confidently with a wide range of subject matter.

Specially devised projects
designed to cover popular subjects.

ROLAND JARVIS displays a distinctive understanding of form in an almost sculptural way, using a combination of line and tone not only for the outline and modelling, but also to say something about the structure, rhythm, balance and proportion of each subject. His evident fluency of line comes from many years of drawing directly from the life model.

GERALD WOODS produces drawings which reflect a feeling for heightened selectivity – distilling the subject in such a way that everything is pared down to bare essentials. He has used different drawing media for this series of projects depending on whether he is going after the structure or atmosphere of the subject, or both.

Techniques and methods
explained clearly and precisely
with easy-to-follow text.

Colour palettes presented
with every project.

Each project is
painted by three different
professional artists.

Inspiring 'critique'
spreads compare
different approaches
and interpretations.

Practical problems
highlighted by the author.

Helpful tips and
advice given by top
professional artists.

Results judged by the
author, based on sound
visual judgement and
practical good sense.

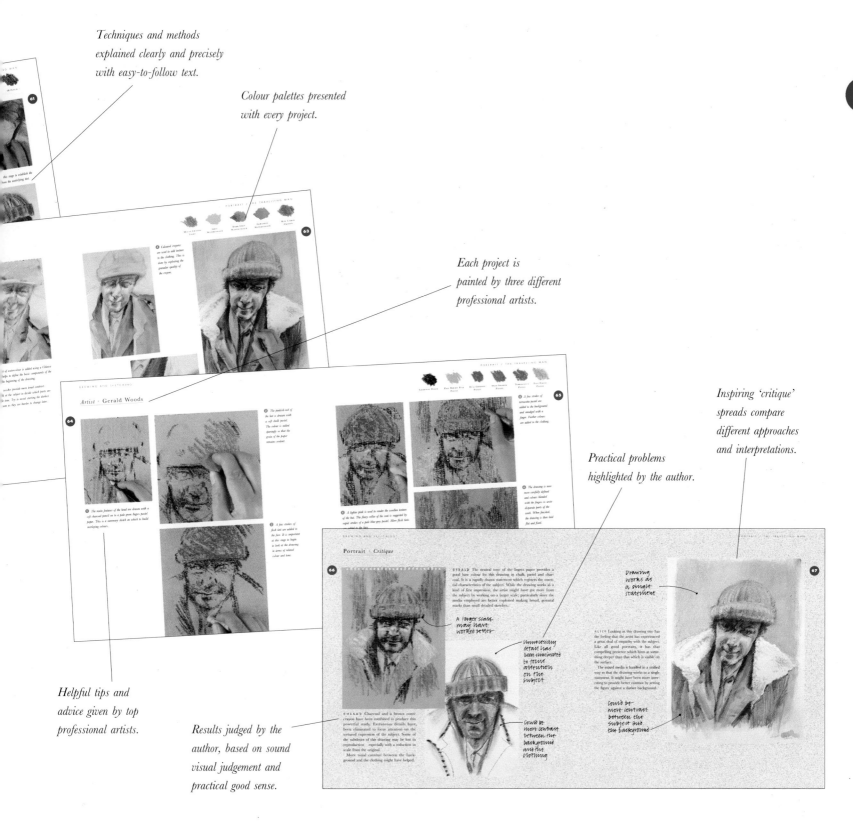

Portrait

A TRAVELLING MAN

Portraiture makes demands on both artist and sitter alike; the close proximity of the subject ensures that some kind of rapport is necessary to the success of the drawing.

Proust once said, 'the human face is really like one of those oriental gods: a whole group of faces juxtaposed on different planes; it is impossible to see them all simultaneously'. This idea that people have different layers or films of appearance was confirmed by the artist Giacometti when he said, 'the adventure, the great adventure, is to see something unknown appear each day in the same face.'

When we draw a portrait, we talk of 'catching a likeness', but a likeness is difficult to define since it is dependent on an enormous variety of intentions on the part of the artist. If one attempts, for instance, to produce a portrait that is pleasing to the sitter, then the drawing will undoubtedly take on a superficiality – like a retouched photograph. If, on the other hand, one tries to uncover some part of the emotional state of the sit-

ter, then something more profound might emerge during the process of drawing.

The subject chosen for this portrait was a French itinerant with a weather-beaten face, puffy eyes, a mottled nose and several days' growth of beard. His face bears the imprint of a life lived roughly on the road. There is a flicker of a smile and the eyes register a kind of tranquil sadness. Only the pink woolly hat adds a note of defiance to his predicament.

You should start a portrait by first deciding how much of the person to include – the head, head and shoulders or three-quarter figure. If the head is conspicuously striking, there is no need to include anything else. Should you feel that the head is not particularly interesting, however, you might include more of the figure and emphasise other characteristics such as the hands or distinctive items of clothing.

It is often a good idea to make thumbnail sketches to work out all the compositional variations.

Artist • Roland Jarvis

OCHRE
CONTE CRAYON

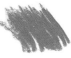
TERRACOTTA
CONTE CRAYON

CHARCOAL

6B PENCIL

1 *The position of the head is quickly established using a stick of brown conté crayon, which is smudged with a finger to soften the tone on the area of the face.*

2 *Continuing to work with the conté crayon, an underlying tint is produced on top of which the first suggestion of the nose and mouth begin to emerge.*

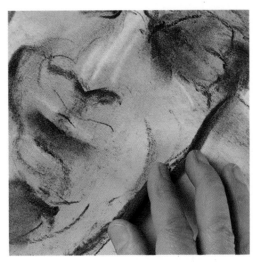

3 *Charcoal is introduced at this stage to establish the form. Highlights are erased from the underlying tint.*

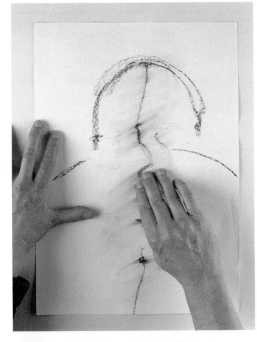

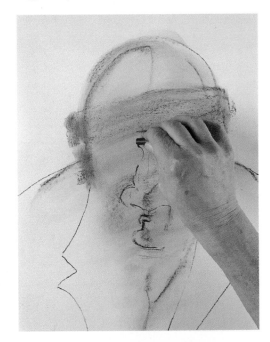

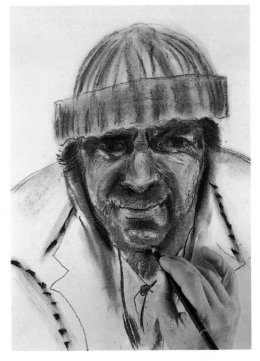

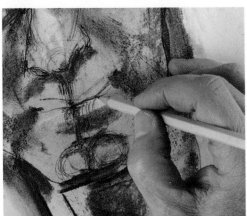

4 *After fixing the drawing at this point, the features of the face are more carefully defined with a soft pencil. The texture and pattern of the hat is briefly stated with alternate strokes of charcoal and brown conté crayon.*

5 *A darker tone is applied with compressed charcoal to consolidate the sense of relief and depth of shadow.*

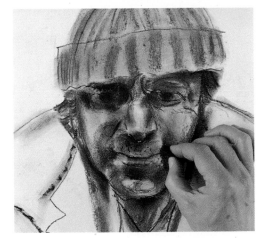

6 *Details such as the eyes, nose and facial hair are rendered with a sharpened 6B pencil.*

Artist • Alice Englander

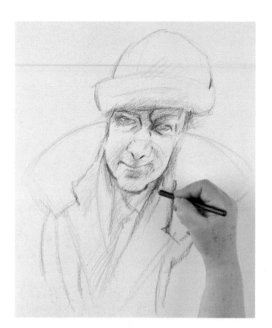

1 *The structure, volume and composition are initially worked out with a crayon of a neutral tint on cartridge paper. At this stage, mistakes are easily corrected.*

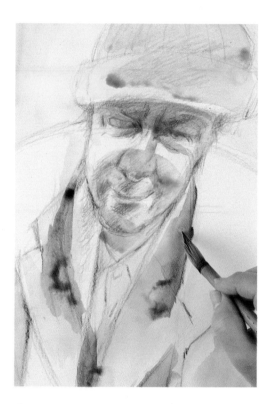

2 *A grey tint of watercolour is added using a Chinese brush. This helps to define the basic components of the drawing at the beginning of the drawing.*

3 *Darker washes provide more tonal contrast. Always look at the subject to decide which parts are of a middle tone. Try to avoid starting the darkest tones too soon as they are harder to change later.*

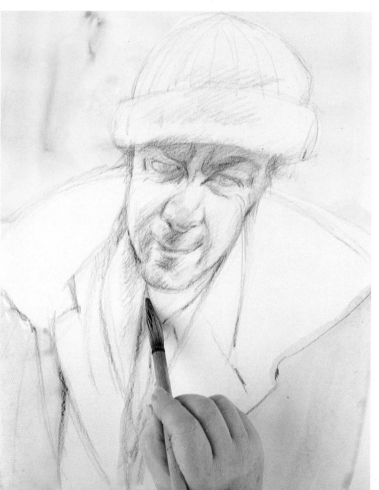

| MAUVE CRAYON LIGHT | GREY WATERCOLOUR | DARK GREY WATERCOLOUR | GERANIUM WATERCOLOUR | RAW UMBER CRAYON |

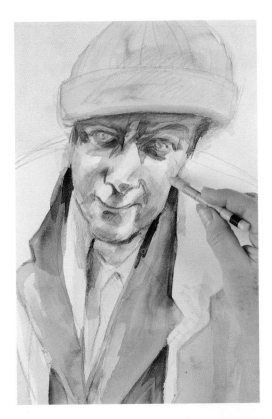

4 *Coloured crayons are used to add texture to the clothing. This is done by exploiting the granular quality of the crayon.*

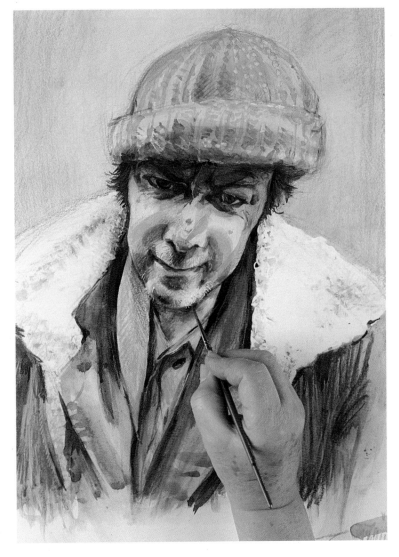

6 *Final details are added using a fine sable brush with watercolour. It is important at this stage not to overwork the drawing and, in so doing, cancelling out the marks made more spontaneously at an earlier stage.*

5 *A water-soluble crayon is used to fill in flesh tints.*

Artist • Gerald Woods

1 *The main features of the head are drawn with a soft charcoal pencil on to a pale green Ingres pastel paper. This is a summary sketch on which to build overlaying colours.*

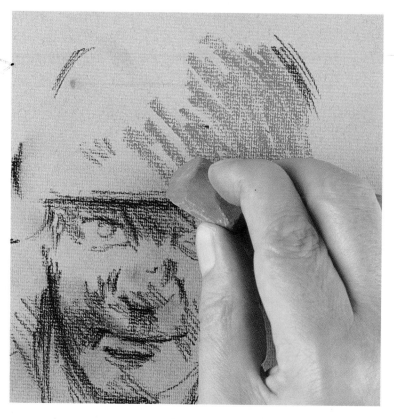

2 *The pinkish-red of the hat is drawn with a soft chalk pastel. The colour is added sparingly so that the grain of the paper remains evident.*

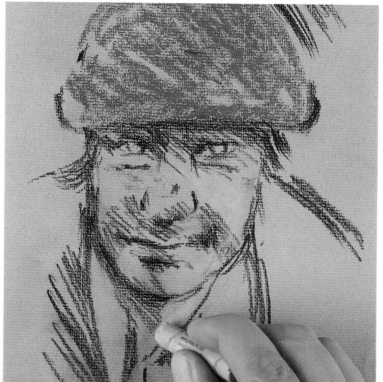

3 *A few strokes of flesh tint are added to the face. It is important at this stage to begin to look at the drawing in terms of related colour and tone.*

CHARCOAL PENCIL. PALE BRIGHT PINK PASTEL DULL CRIMSON PASTEL DEEP SHADOW PASTEL TERRACOTTA PASTEL PALE EARTH PASTEL

65

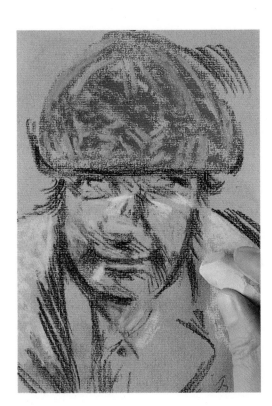

❹ *A lighter pink is used to render the woollen texture of the hat. The fleecy collar of the coat is suggested by rapid strokes of a pale blue-grey pastel. More flesh tints are added to the face.*

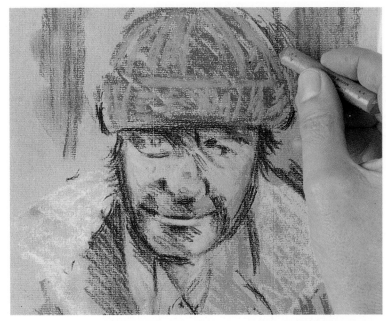

❺ *A few strokes of terracotta pastel are added to the background and smudged with a finger. Further colours are added to the clothing.*

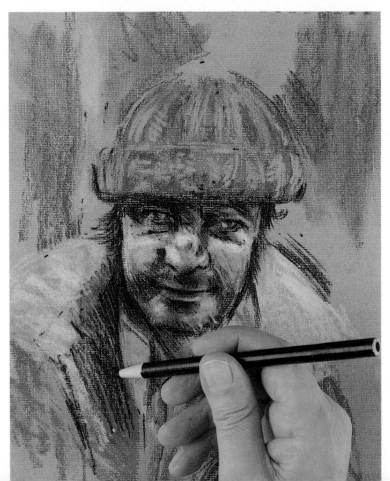

❻ *The drawing is now more carefully defined and colours blended with the fingers to unite disparate parts of the work. When finished, the drawing is then laid flat and fixed.*

Portrait · *Critique*

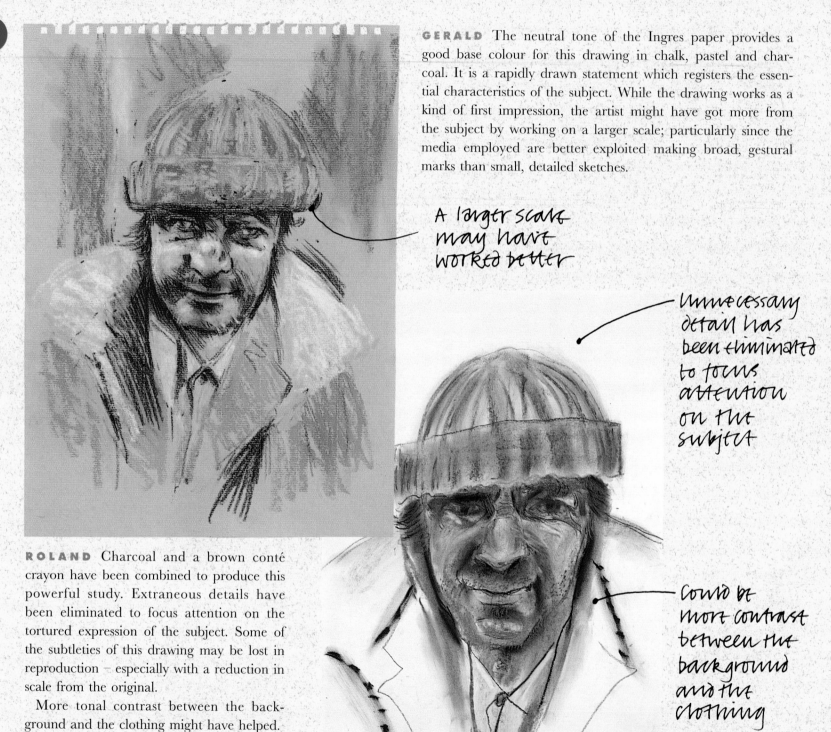

GERALD The neutral tone of the Ingres paper provides a good base colour for this drawing in chalk, pastel and charcoal. It is a rapidly drawn statement which registers the essential characteristics of the subject. While the drawing works as a kind of first impression, the artist might have got more from the subject by working on a larger scale; particularly since the media employed are better exploited making broad, gestural marks than small, detailed sketches.

A larger scale may have worked better

Unnecessary detail has been eliminated to focus attention on the subject

ROLAND Charcoal and a brown conté crayon have been combined to produce this powerful study. Extraneous details have been eliminated to focus attention on the tortured expression of the subject. Some of the subtleties of this drawing may be lost in reproduction – especially with a reduction in scale from the original.

More tonal contrast between the background and the clothing might have helped.

Could be more contrast between the background and the clothing

Drawing
works as
a single
statement

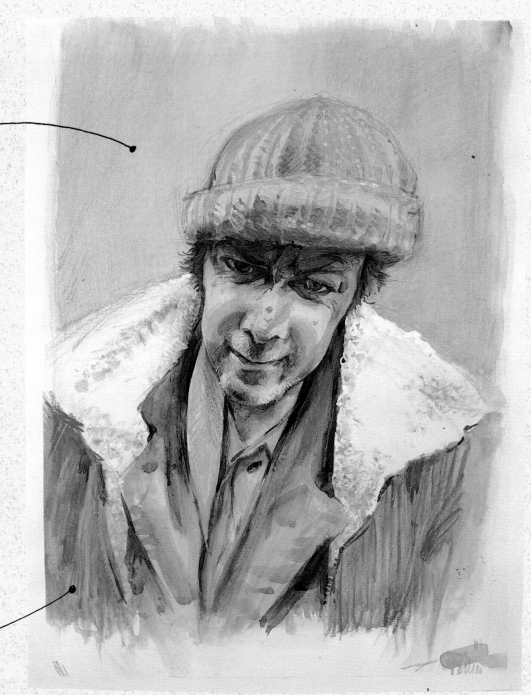

ALICE Looking at this drawing one has the feeling that the artist has experienced a great deal of empathy with the subject. Like all good portraits, it has that compelling presence which hints at something deeper than that which is visible on the surface.

The mixed media is handled in a unified way so that the drawing works as a single statement. It might have been more interesting to provide better contrast by setting the figure against a darker background.

could be
more contrast
between the
subject and
the background

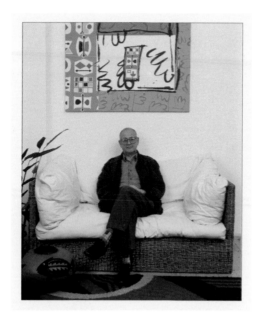

Seated Figure

AN ARTIST AND HIS WORK

For this project we are required to produce a kind of double portrait; a contemporary artist is seen beneath one of his own paintings, which presents us with an interesting subject. There is a fascinating relationship between the lively calligraphic strokes of the painting, and the almost contemplative tranquillity of the artist himself. Additionally, the artist and his work are seen as related elements against the broader canvas of the white space of the studio wall.

Seated figures are sometimes difficult to deal with in terms of drawing. In this instance, all of the weight of the figure is absorbed by the pelvis on the soft cushion. The left leg crossed over the right projects forward and, if this drawing is to be convincing, we need to convey this in terms of perspective. When perspective is applied to a single object such as an arm or a leg, it is called foreshortening.

Artist · Roland Jarvis

PRUSSIAN BLUE
LIGHT WASH

PRUSSIAN BLUE
DARKER WASH

BLACK INK

PEN AND INK

1 *The position of the seated figure is suggested with broad strokes of an inky-blue wash of watercolour applied with a sable brush.*

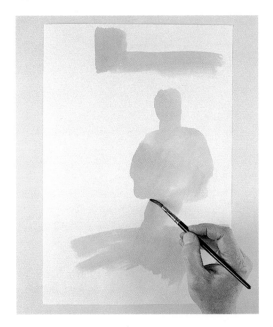

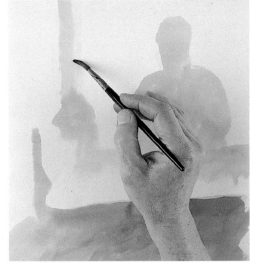

2 *A further wash is added to the floor and surrounding the cushion of the rattan seat.*

3 *Broad calligraphic strokes are made with a finer sable brush to render the details of the plant, pot and the painting above the figure.*

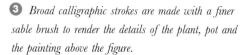

69

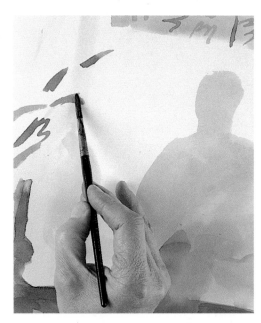

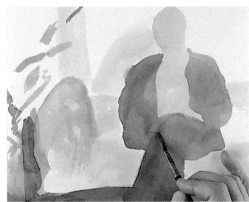

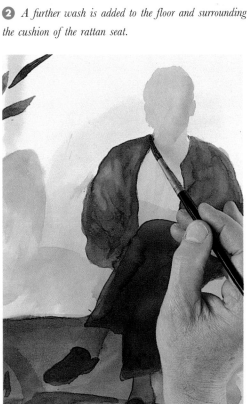

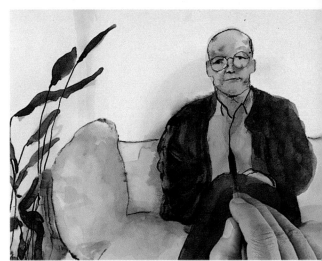

4 *Darker tones of the same colour are applied to the clothing of the figure and to the foreground.*

5 *A wash of black Indian ink provides some tonal contrast. The paper is dampened slightly to allow the wash to spread unevenly.*

6 *Finally, the washes are held together with an outline in pen and ink – this is done with restraint to avoid overworking the drawing.*

Artist • Alice Englander

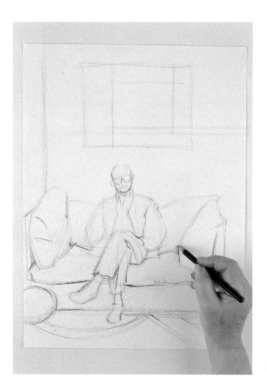

1 *First, the main compositional details are established with a neutral-toned wax crayon on Bockingford paper. Everything is balanced on a central axis with the figure seated directly under his canvas.*

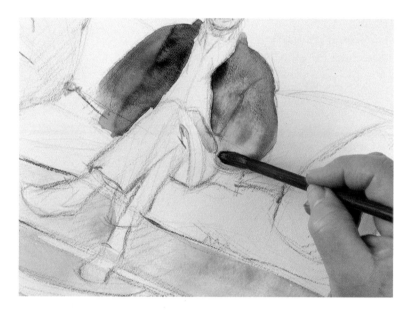

2 *A coloured under-drawing is produced with pale washes of watercolour using a Chinese brush.*

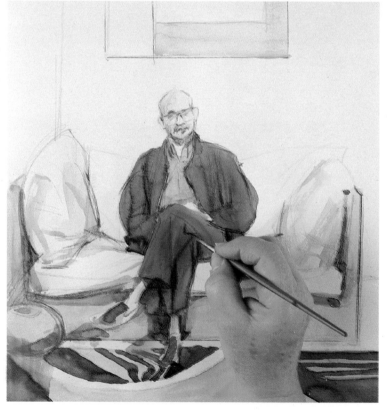

3 *Details such as creases in the clothing are painted with a fine sable brush. In any mixed-media drawing, different parts can be given emphasis by using a brush, pencil or chalk.*

PURPLE CRAYON

YELLOW OCHRE
WATERCOLOUR

MID-GREY WASH
WATERCOLOUR

PRUSSIAN BLUE
WATERCOLOUR

VIRIDIAN
WATERCOLOUR

INDIAN RED
WATERCOLOUR

BLUE CRAYON

CADMIUM ORANGE
GOUACHE

71

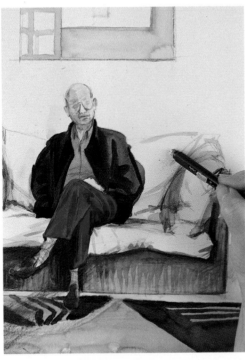

4 *The underlying drawing is erased and corrections are made with white gouache. The whole process of cancelling out marks and re-stating them can continue until judged to be right.*

5 *The whole drawing is now given greater definition as tones are further modulated.*

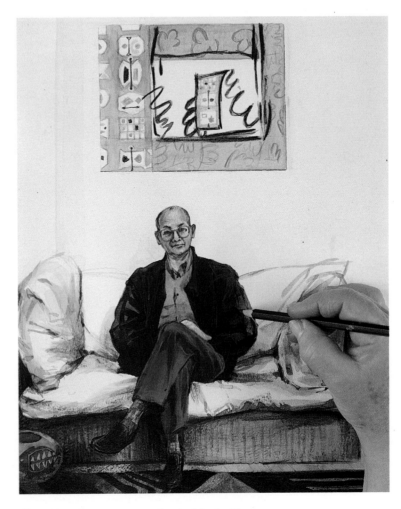

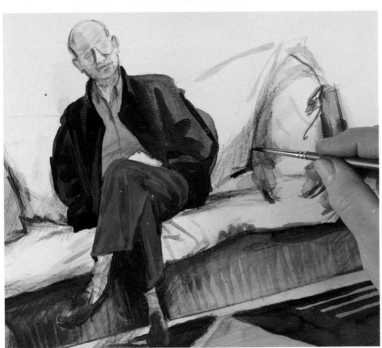

6 *Folds and creases are more sharply defined with a coloured drawing pencil. Broken contours suggest modelling of the form. The artist has to imply the potentiality of movement when drawing the human figure.*

Artist • Gerald Woods

1 *The main connective angles are briefly stated with an HB pencil on white cartridge paper.*

2 *The drawing continues in a restrained way – emphasising the two-dimensional qualities rather than attempting to create the illusion of depth. A grey crayon is used to provide an additional half-tone.*

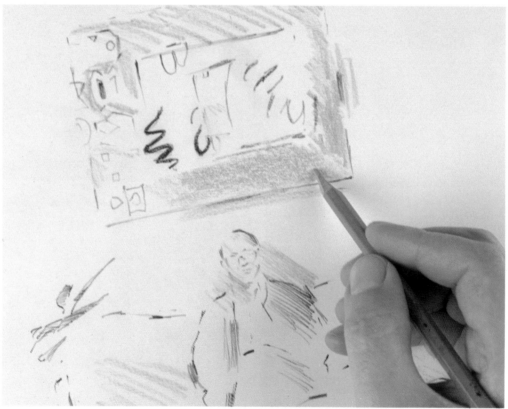

3 *The orange colour of the painting in the background is picked out with a wax crayon.*

HB PENCIL GREY CRAYON ORANGE CRAYON ULTRAMARINE
 CRAYON
 YELLOW OCHRE
 CRAYON

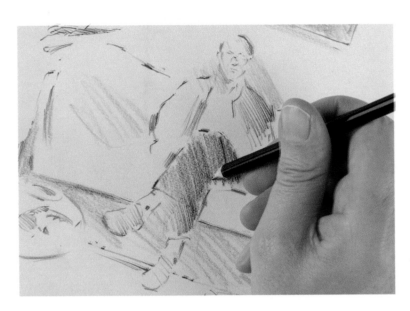

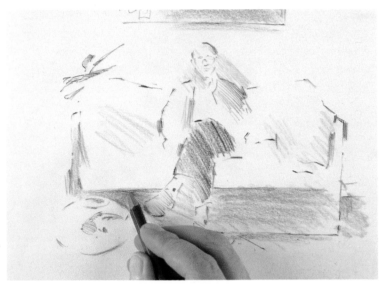

4 *The shape of the folded legs is defined with a blue crayon.*

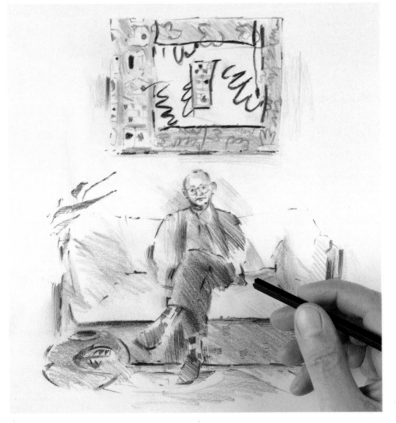

5 *Yellow ochre is added sparingly to the rattan chair. It is critical at this stage to consider the tonal balance of the whole drawing.*

6 *The pencil drawing is resolved without overstatement and touches of indigo, orange and ochre crayon are added to the figure, painting and foreground.*

Seated Figure • *Critique*

74 **ALICE** In this deceptively simple composition there are, in fact, a lot of things to contend with. Aspects of drawing which appear effortless are often the result of considerable premeditation on the part of the artist. What strikes me most about this drawing is not whether the artist has produced a good 'likeness', but the convincing way in which she has managed to suggest the sense of the weight of the figure sinking into the soft cushions on the rattan chair.

Watercolour, gouache and coloured crayons have been combined effectively to deal with a variety of textures, from fabrics to pottery and woven cane. From a compositional standpoint, one might feel that everything is too ordered. Conversely, however, such equilibrium might be entirely appropriate to the subject.

Effective use of watercolour, gouache and coloured crayons

Convincing suggestion of weight of the figure

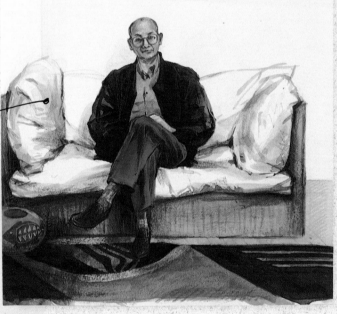

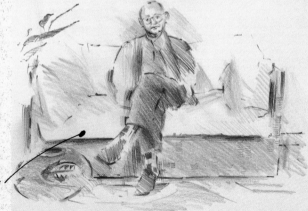

Should have moved closer to the subject

GERALD In this rapidly drawn statement, the artist has sought to register only the bare essentials of the composition. Everything is treated in equal terms, so that a pot or a cushion or the figure itself are seen simply as related objects in space.

Everything has been transposed and subliminated into a two-dimensional pattern which is reminiscent of the painting in the background.

From a compositional standpoint, one might wish that the artist had moved a little closer to the subject.

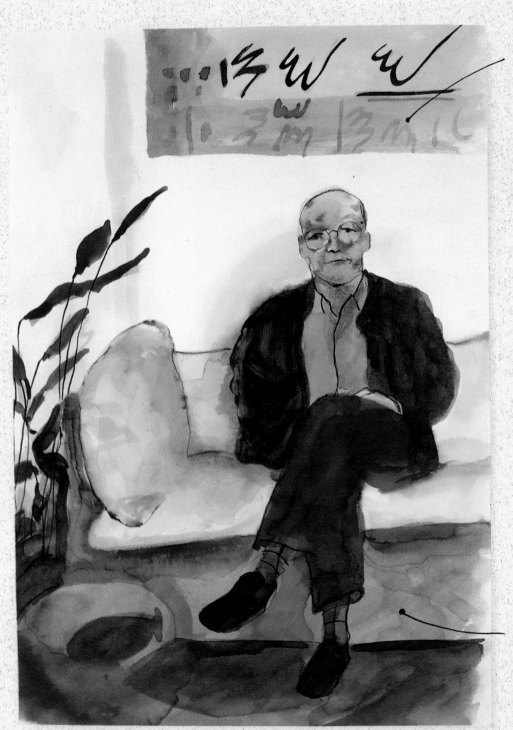

Everything rendered as a two-dimensional pattern

ROLAND Whether or not a likeness has been achieved depends very much on the artist's intentions. This is an unusual and intelligent approach to the problem of depicting an artist seen with one of his own works in the background. Instead of seeing the subject in terms of separate and isolated elements, the artist has attempted to incorporate the calligraphic quality of the painting that we see in the background in terms of the quality of the marks used for the drawing as a whole. Rather like a Chinese painting, everything is seen as a two-dimensional pattern, avoiding the illusionism of perspective.

By moving close to the subject, the composition becomes more interesting, as everything becomes truncated and the section of the painting which occupies the top right-hand corner becomes almost an extension of the figure and other elements in the drawing.

Interesting composition achieved by moving closer to the subject

Interior

SWIMMING POOL

For this project it was necessary for the artists to use photographic reference for their drawings, instead of working directly from the subject. Because none of the shapes and forms are ever constant, there is a need to get some kind of fixed reference.

Photographic reference, however, should be used in the right way; it is important not to slavishly reproduce the smooth, silvery tones of the print, but to use the information as a starting point. The shapes made when people splash around in water are difficult to render in terms of drawing techniques. It can help to restrict the range of tones in a monochromatic way or, if using colour, to use colours of the same hue. It is interesting to see how the human form is distorted and deflected by immersion in water, producing abstracted shapes which force one to consider the subject in an entirely objective way.

Artist • Roland Jarvis

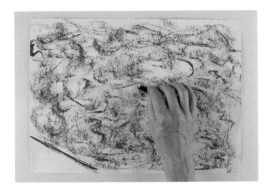

1 *The overall effect of water is achieved by drawing with a wedge-shaped piece of charcoal.*

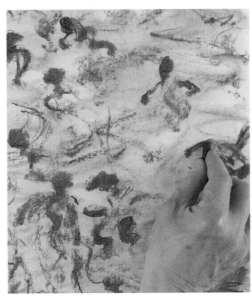

2 *The relative position of individual swimmers is roughly indicated.*

3 *Patches of light on the water and on the figures are picked out from the existing tone with the edge of a putty rubber.*

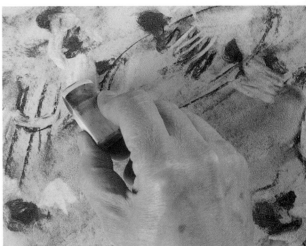

4 *Tones are blended with a finger and the drawing is developed while at the same time the artist tries to maintain spontaneity and a sense of movement.*

5 *Working with a stem of charcoal, the tonal pattern is consolidated to evoke the atmosphere of the swimming pool by varying the pressure on the paper.*

6 *Highlights are lifted out of the overall tone with the edge of a putty rubber.*

Artist • Alice Englander

1 *Drawing with an HB pencil, the exact action and placement of the figures is established within the overall composition.*

2 *Using a dip pen and waterproof Indian ink, the drawing is re-stated.*

3 *The ink drawing is allowed to dry and the underlying pencil lines are erased. The pen provides a keyline on which to lay further washes of colour and to build up the drawing generally.*

HB PENCIL PEN AND INK COBALT BLUE WATERCOLOUR LEMON YELLOW WATERCOLOUR ALIZARIN CRIMSON WATERCOLOUR PRUSSIAN BLUE CRAYON LITHO CRAYON

79

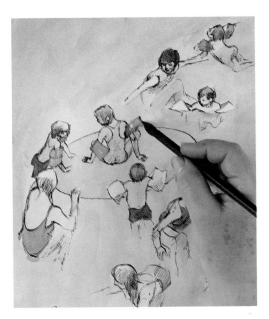

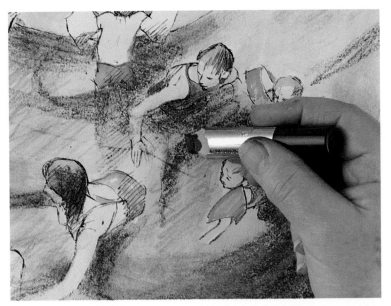

5 *The broken texture of a dark blue-grey crayon is used broadly to emphasise the rhythm and oscillation of the water.*

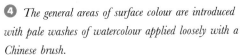

4 *The general areas of surface colour are introduced with pale washes of watercolour applied loosely with a Chinese brush.*

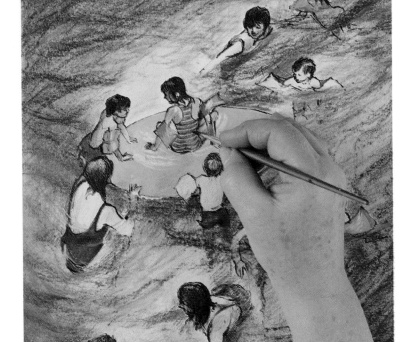

6 *Details are added to the figures and the primary colours of floats, armbands and swimming costumes with a fine brush, watercolour and coloured crayons.*

Artist · Gerald Woods

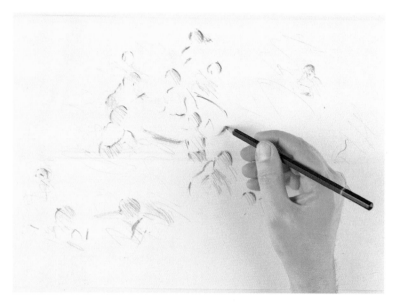

1 *The relative positions of the fifteen swimmers are roughly drawn with a 3B pencil on buff-coloured cartridge paper.*

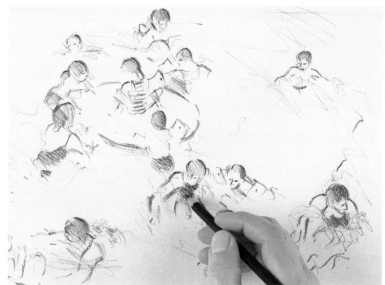

2 *The drawing is further consolidated with a softer 6B pencil.*

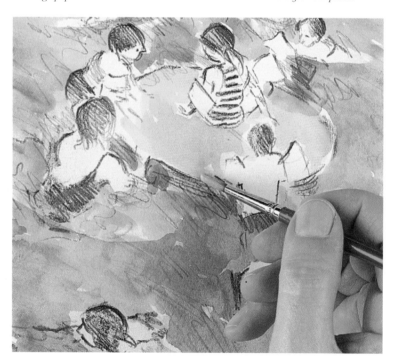

3 *A freely applied wash of Monastral Blue is laid over the drawing, isolating and defining the swimmers and those parts of their bodies above and below the surface of the water.*

3B PENCIL

6B PENCIL

MONASTRAL BLUE

LEMON YELLOW

TURQUOISE

PRUSSIAN BLUE
WATERCOLOUR

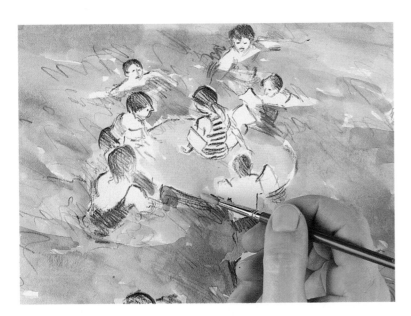

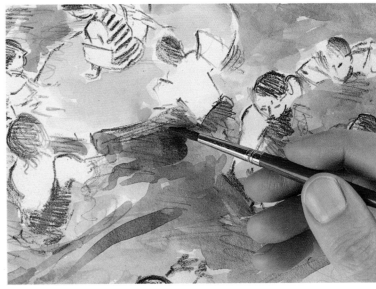

4 *A full wash of Lemon Yellow defines the shape of the inflatable raft.*

5 *Further washes of turquoise and French Ultramarine are overlaid wet-in-wet to create the effect of dappled water.*

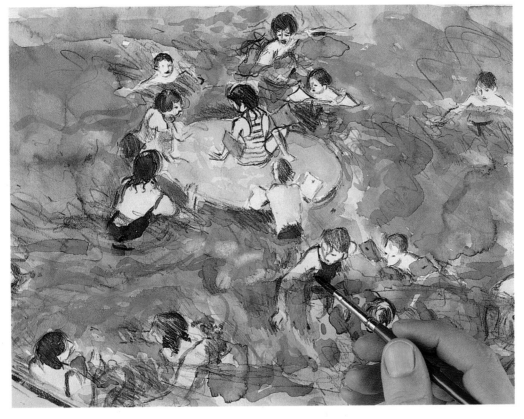

6 *Parts of the drawing are given more definition with a wash of Prussian Blue using a No. 4 sable brush.*

Interior · *Critique*

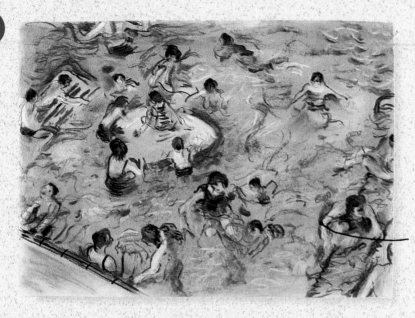

ROLAND This lively drawing suggests colour even though it is produced in monochrome. The rhythm and spontaneity has been maintained throughout the various stages of development. One senses that the artist was particularly engaged in the early stages with the intrinsic movement of half-submerged figures and he has used charcoal in a very dynamic way. Something of this is lost, I feel, in the final stage of the drawing.

Sustained rhythm and spontaneity throughout

Effective use of watercolour

Too many points of focus

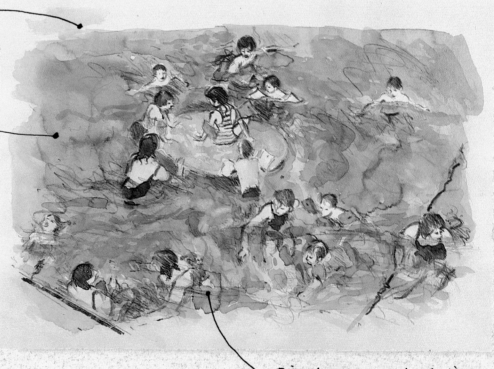

GERALD Watercolour has been used effectively in this drawing to convey the quality of opalescence of the pool. Additionally, the transparency of the medium helps to reinforce the impression of the buoyancy of the swimmers. In terms of composition, however, the displacement of the figures could have been more interesting, since in the existing drawing there are too many different points of focus.

Displacement of figures not very interesting

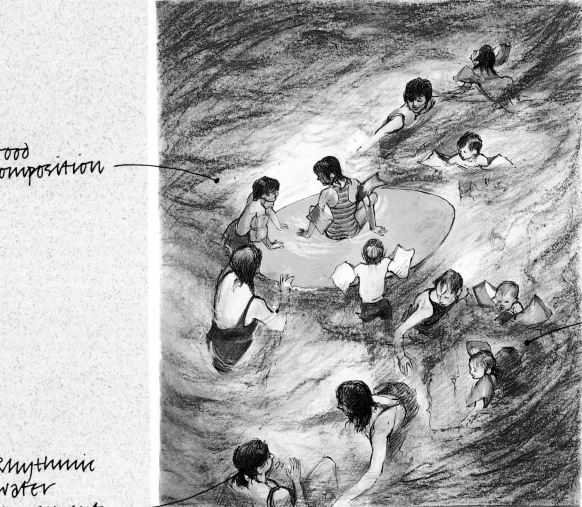

Good composition

Fluent use of pen & ink

Rhythmic water movement

ALICE In this drawing, the artist has given careful consideration to the composition. Notice, for instance, the diagonal link of arm movements from the figure in the bottom left-hand corner to the figure in the top right-hand corner.

Drawing figures in movement calls for economy of line and the artist has used pen and ink with considerable fluency.

In the final stage of the drawing, she has used coloured crayons to create a rhythmic movement of the water and, while this is convincing, it is more reminiscent of the choppy texture of the open sea than of a swimming pool.

Animal Study

LITTLE DOG

Unless you are one of those people who actively dislike domestic pets, it is difficult not to be moved in some way by the pathos of the dog chosen for this drawing project.

The eyes are a key to the expression lending a sparkle of wry humour to what might otherwise be a rather dull subject.

Although I can assure the reader that the dog is a living specimen, he actually looks like the product of a taxidermist who is none too skilled in his profession. This stiffness of stance, which is reflected in the drawings, is due in part to the age of the dog. The chain provides a kind of visual link to the unseen presence of the owner.

Artist • Roland Jarvis

CHARCOAL

6B PENCIL

COMPRESSED
CHARCOAL

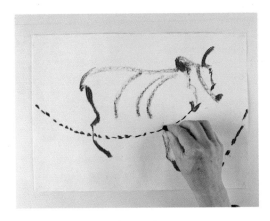

1 *The basic outline is quickly established in broad strokes of charcoal.*

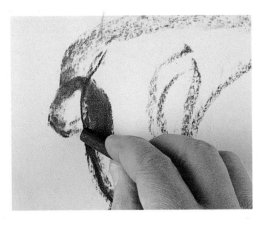

2 *Features such as the ears, nose and hind legs are added with a sharp stem of charcoal.*

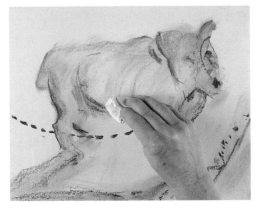

3 *The whole drawing is now gently wiped with tissue paper to produce a ground for successive states of the drawing.*

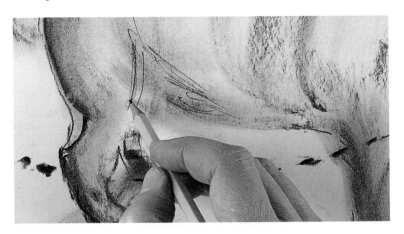

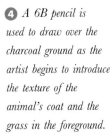

4 *A 6B pencil is used to draw over the charcoal ground as the artist begins to introduce the texture of the animal's coat and the grass in the foreground.*

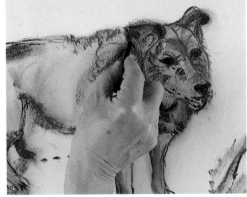

5 *The drawing is partially erased and corrected. Certain passages are redrawn with compressed charcoal to lend more definition to the features of the animal.*

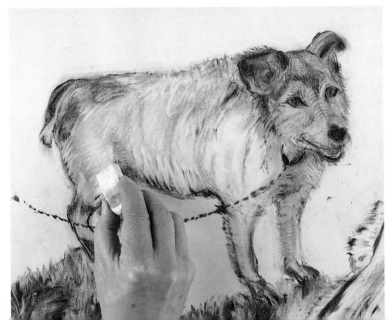

6 *The process of cancelling out parts of the drawing and re-stating the image continues until the right balance is achieved.*

Artist • Alice Englander

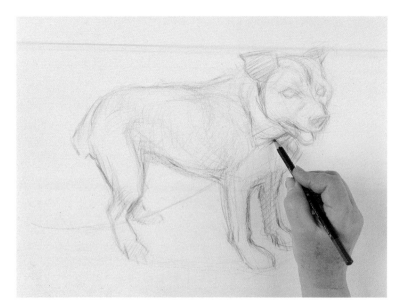

1 *The construction of the animal is carefully worked out using a neutral grey crayon on Bockingford paper.*

2 *A pale green is washed into the background with watercolour and a Chinese brush. When dry, the underlying crayon is erased.*

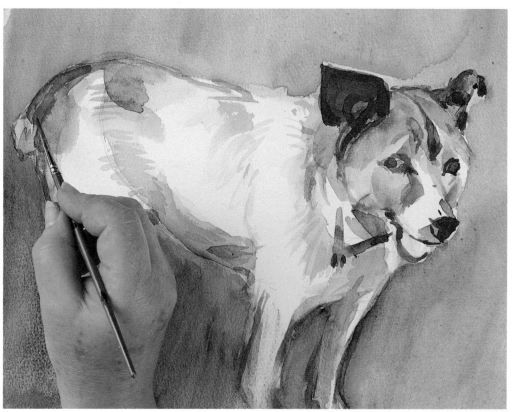

3 *Details on the head and body of the animal are established with a finer brush and alternate washes of Raw Sienna and Burnt Umber.*

GREY CRAYON

PALE GREEN
WATERCOLOUR

RAW UMBER
WATERCOLOUR

BURNT UMBER
WATERCOLOUR

BLACK CRAYON

INDIGO CRAYON

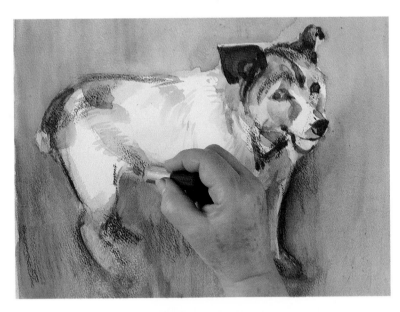

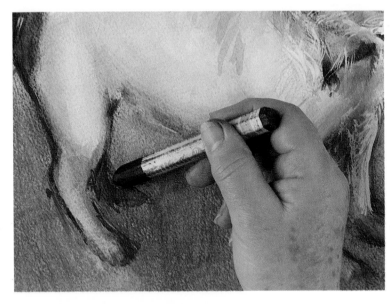

4 *A granular tone is overlaid at this stage using the edge of a soft black crayon.*

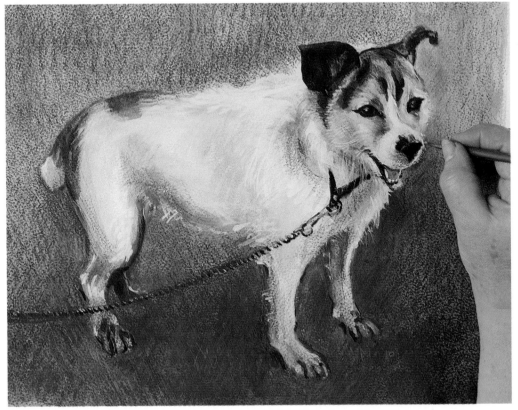

5 *Background tones are diffused with a soft indigo-coloured wax crayon.*

6 *All the white lights are refined with opaque white gouache and a fine sable brush. Background tones are modulated with wax crayons, using the grain of the paper for added texture.*

Artist • Gerald Woods

2 *A pale tint of brown is introduced to the fur around the eyes and tail.*

1 *The main form of the dog is drawn sparingly with just a few pencil strokes.*

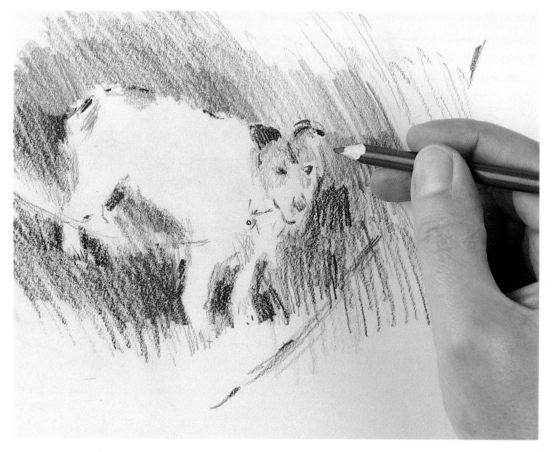

3 *At this stage, the white surface of the paper becomes an element of the drawing — the white coat of the dog is created by isolating the form with green shading.*

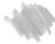

6B PENCIL. OCHRE CRAYON PALE GREEN MID-GREEN MID-GREY BLACK CRAYON VANDYKE BROWN
CRAYON CRAYON CRAYON CRAYON

89

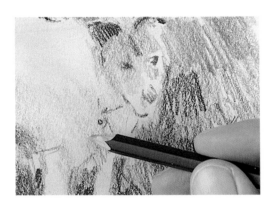

4 *Using a mid-grey wax crayon, the tone around the dog is intensified.*

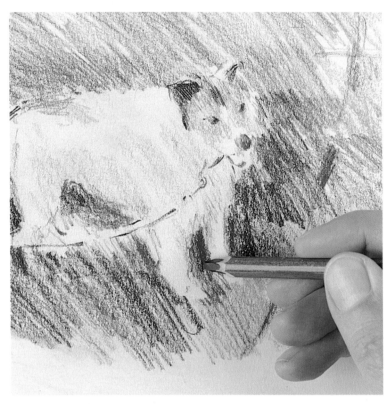

5 *A dark Vandyke Brown crayon provides strong tonal contrast.*

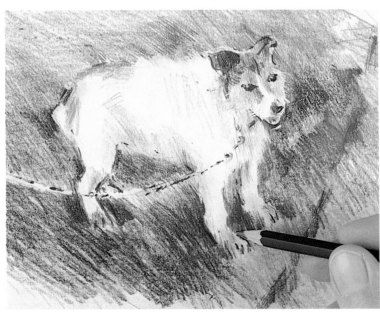

6 *In the final stage, the drawing is completed with a sharpened black crayon and colours which have accrued in previous stages are more carefully blended.*

Animal Study • *Critique*

90

ROLAND It is interesting to follow the development of this drawing, from the first skeletal marks through different states of construction, to the final delineation. Like all good drawings, it has been produced in terms of the medium – that is to say, the artist has used charcoal in such a way that the properties of the medium are fully exploited in the translation of an idea.

The simplicity of the composition and the careful control of the tonality help to produce a convincing drawing which avoids sentimentality.

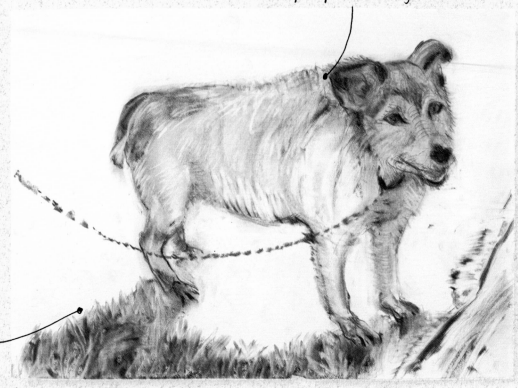

Full exploitation of the properties of charcoal

simple composition

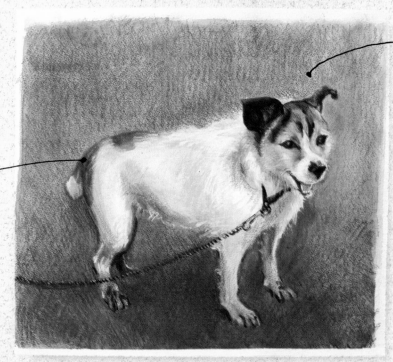

skilful handling of mixed media

Effective use of dry brush technique

ALICE It is difficult to avoid overt sentimentality when producing an animal portrait. In this respect, I much prefer the earlier stages of the drawing to its final state. Having said that, however, there is no doubt that the finished drawing demonstrates a skilful handling of mixed media to produce a convincing interpretation of the subject. The use of dry brushwork to render the mange-like quality of the fur is particularly effective. The expression and stance of the animal are also handled well.

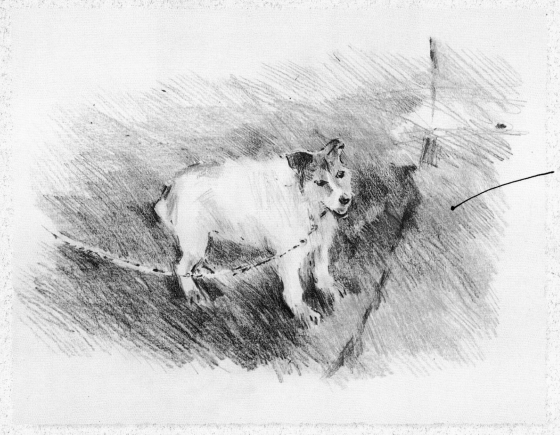

More a
sketchbook
study than
a finished
drawing

GERALD In this drawing we see the animal in the context of a scrubby patch of urban parkland. In a sense, this helps to reinforce the pathos of the subject. This is the kind of notation one would expect to find in a sketchbook – perhaps as part of a sequence of inconsequential studies of the kind of things one sees in a public park in any town or city.

It is the kind of drawing which is more likely to impress by its fragility than by its strength.

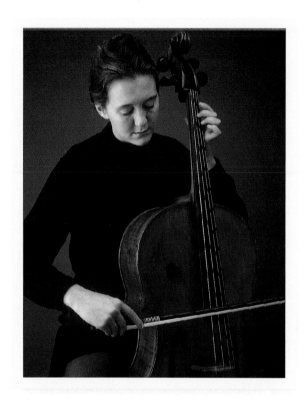

Unposed Figure

YOUNG CELLO PLAYER

I find that drawing someone who is engaged in some occupation or other is often more inspiring than drawing someone who is posing specially for a portrait. The subject is at once relaxed and unselfconscious, absorbed in whatever they are doing rather than uncomfortably aware of the artist. Some of the most interesting drawings produced by the French Impressionists were their inconsequential studies of men, women and children idly engaged in casual pursuits – cooking, sewing, reading and so on. Edward Vuillard (1868–1940) spent most of his life drawing and painting such scenes of domesticity as did Berthe Morisot (1841–1895) and the American artist Mary Cassatt (1844–1926).

Drawing musicians requires the ability to produce settled images from things that move a little. I was once invited to make a series of drawings at rehearsals for the annual music festival in Luzern, Switzerland. I remember that at first I found it difficult to come to terms with the need to draw rapidly, in an almost automatic way. It was only some hours after the rehearsals were over that I could look at my sketches and evaluate what had been achieved.

The young cellist selected for our drawing is seen concentrating on the action of drawing the bow across the instrument, while making finger movements instinctively with her left hand. Musician and instrument appear to be inextricably linked.

Artist • Roland Jarvis

CHARCOAL

PENCIL (2B)

93

❶ *The artist begins by making a rapid 'shorthand' analysis with charcoal, indicating the main rhythms and proportions of the subject. An advantage of working in this way is that you get rid of the blankness of the paper immediately – thus providing a framework for the whole drawing.*

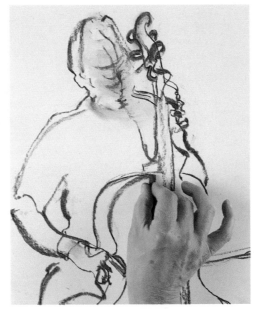

❷ *A linear rendering of the form continues with charcoal, applying strokes of varying pressure and intensity.*

❸ *Some redrawing occurs at this stage as tones are broadly established.*

❹ *The eraser is used as a drawing tool to produce lighter patches.*

❺ *Details on the face, hands and instrument are additionally drawn with a 2B pencil.*

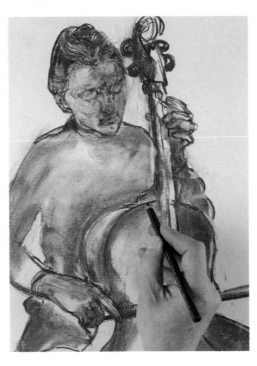

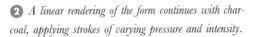

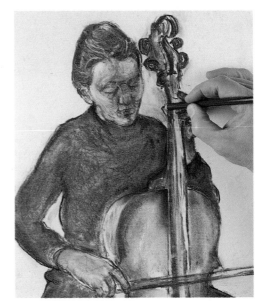

❻ *The drawing is balanced tonally and final detail is added with a sharp 2B pencil.*

Artist • Alice Englander

94

1 *The figure and instrument are drawn using a neutral tint of coloured crayon on cartridge paper. Gradations of tone are added selectively with the same crayon.*

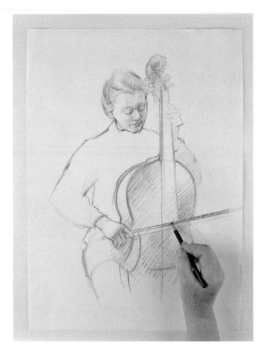

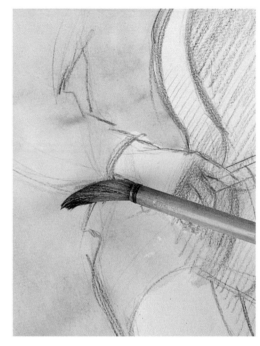

2 *A wash of Payne's Grey is painted over both figure and background with a Chinese brush to produce a unified tone.*

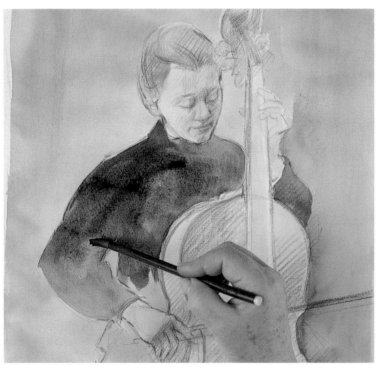

3 *Colour is added to the hair, clothing and cello, with broadly laid washes of watercolour. The drawing is built up gradually by giving consideration to all the related elements.*

PURPLE CRAYON PAYNE'S GREY WASH YELLOW OCHRE BURNT UMBER LAMP BLACK BLACK LUMBER CRAYON

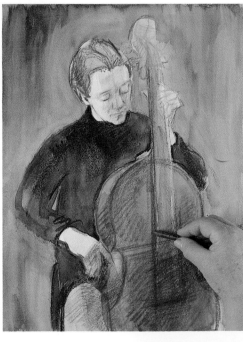

4 *A brown wax crayon produces tones which suggest the patina of the polished surface of the cello.*

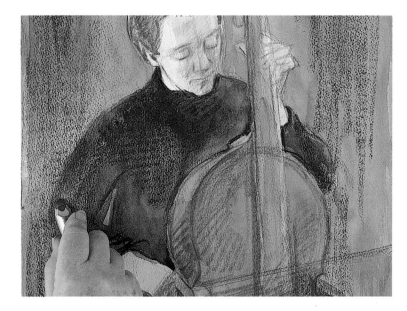

5 *Tones are further modulated using a combination of watercolour, coloured crayons and a black lumber crayon.*

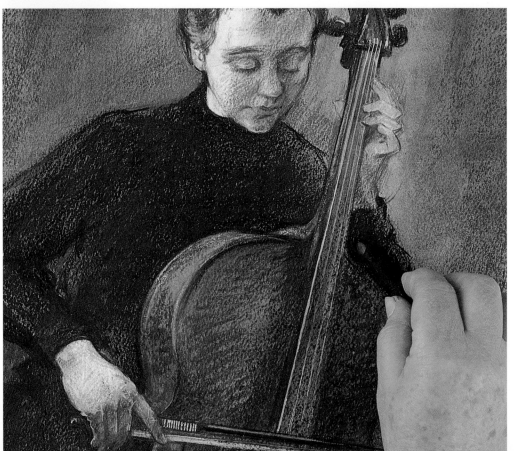

6 *The previously laid black washes are given greater intensity by drawing on top with a soft wax crayon. More detail is added to face, hair, hands and cello.*

Artist • Gerald Woods

2 *Shading with a softer graphite pencil follows the rounded forms of the figure and cello.*

1 *A few marks with a soft pencil on grey Ingres paper register the main corresponding angles of the figure and instrument.*

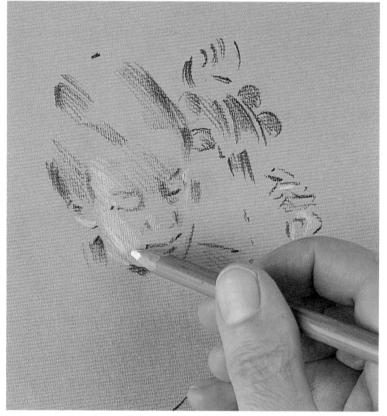

3 *Tones are intensified but the drawing remains deliberately understated. A white crayon is used for highlights on the face, hands, strings and bow.*

2B PENCIL 6B PENCIL 9B PENCIL BROWN CRAYON GREY CRAYON

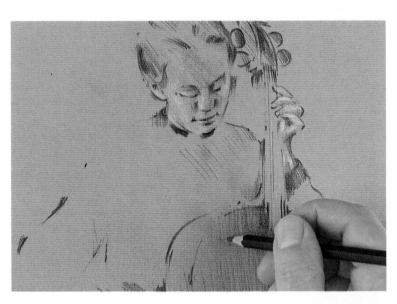

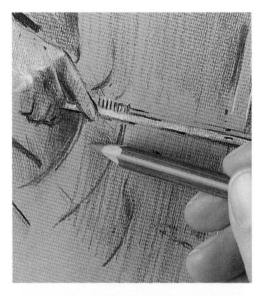

5 *Brown shading is added to the surface of the cello, but colour is hinted at rather than overstated.*

4 *At this stage the artist gives careful consideration to the corresponding arcs and angles of both the figure and the instrument, intensifying the tone as necessary with a 9B pencil.*

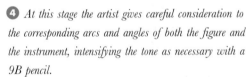

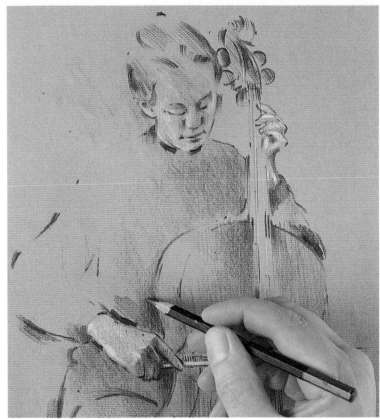

6 *A mid-grey half-tone is added with a wax crayon.*

Unposed Figure • *Critique*

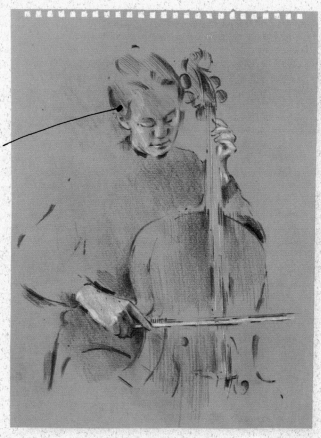

Deliberate under-statement

GERALD In this drawing, the artist has consciously aimed at the understatement, registering only those aspects of the pose which are necessary to communicate what is happening. Such a drawing calls for a certain amount of premeditation on the part of the artist, since one is concerned with evaluating just how much can be left out. The success or failure of the drawing is dependent on the assumption that the viewer will make the necessary connections from their own memory and from the information provided.

Fingering of the instrument well-observed

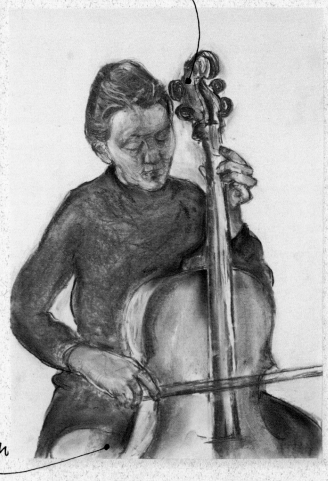

ROLAND The arabesque-like marks made in the early stage of the drawing are analogous to musical notations. This overriding sense of rhythmicity is maintained in the final stage particularly in the way that the fingering of the instrument has been depicted. The tonality of the drawing also evokes the idea of a melodic fugue.

This is a good example of a drawing that is concerned more with interpretative values than with exactitude. My own feeling, however, is that the drawing would have had even more resonance if the artist had worked to the same scale on a much larger sheet of paper.

Good interpretation of the subject

Well-caught pose

Textures drawn convincingly

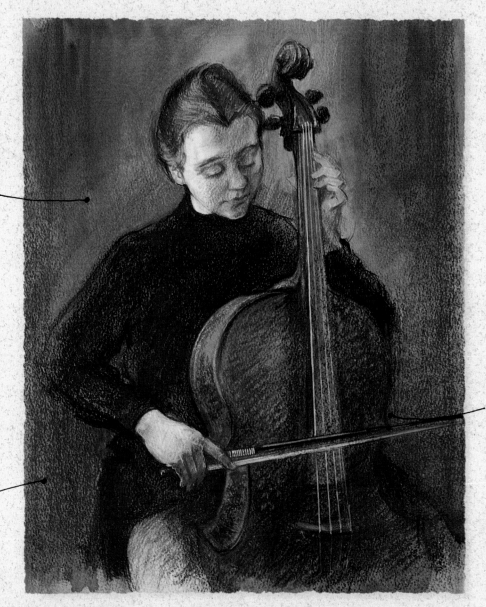

Skilful control of colour and tone

ALICE In the first stage of the drawing, the artist has captured the essence of the pose. All the concentrated effort that is evident when a musician is at one with their instrument is made manifest in this drawing. In the final stage, colour and tone have been skilfully controlled to retain the intentness of the performance. The dark tone of the background serves to enhance the isolated patches of light on the face and hands.

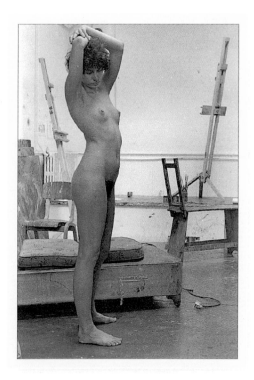

Life Study

STANDING NUDE

Standing poses can sometimes prove difficult for both artist and model. The sense of weight becomes more critical, one leg usually bearing more weight than the other so that there is a need to establish right away the vertical axis which is supportive to the rest of the body.

The particular contribution that can be made by the model to the success of the drawing is often underestimated. In this instance, the model participated fully in the drawing session by trying to anticipate the requirements of the artists who were drawing her. The strongly vertical stance was achieved gradually. A number of alternative positions were tried out before the artists in the session settled for this final pose.

It is interesting to note the relationship between the model and the displacement of other objects in the room. All the horizontal and vertical structures provide a link to the composition as a whole. Additionally, they provide a most useful means of cross-reference when trying to establish the proportions of the figure. Keep this in mind when setting a pose.

Degas once said that, 'drawing is not the imitation of the form, it is the manner of seeing the form.' The task facing the artists responding to this pose is to create the right balance between a detached objectivity and a sense of heightened reality, which is more subjective, emphasising the strongly rhythmic elements of the pose.

Artist • Roland Jarvis

SOFT PENCIL CHARCOAL

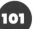

1 *Using a broken stem of willow charcoal, the basic rhythm of the pose is rapidly drawn.*

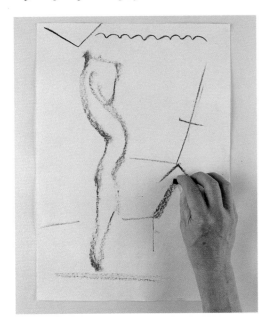

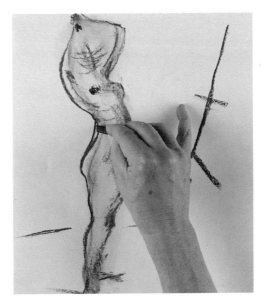

2 *The main accents of corresponding arcs of the figure are indicated and parts of the drawn line are wiped softly to produce a flat tone over the whole figure.*

3 *The curvature of the torso is emphasised with directional strokes of charcoal. The modelling of the form is developed as a single statement.*

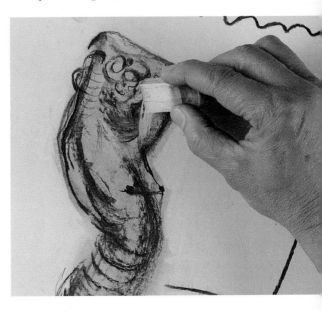

6 *The main compositional elements in the background are now linked to the figure with charcoal to produce a sense of space and to give the figure a context.*

4 *Highlights are erased with a putty rubber and the main forms are re-stated with a medium grade pencil without being too precise at this stage.*

5 *With a softer pencil, the artist now works from the larger forms towards the smaller with a sensitive, more tentative line, producing rich tonal variations.*

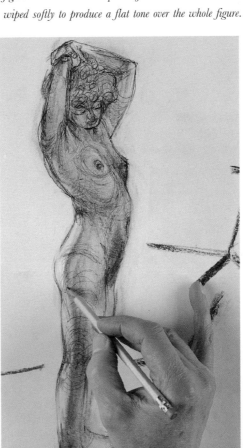

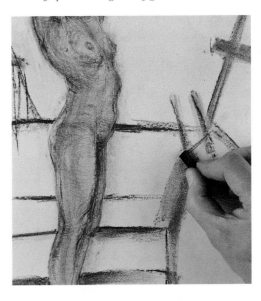

Artist • Alice Englander

1 *The structure of the figure and the movement of the pose is registered lightly with a soft graphite pencil on cream-coloured laid paper.*

2 *Further tone is added tenuously with a lithographic pencil to express the volume of the form on the broken texture of the paper.*

3 *Earlier detail is now lost as broader tones are overlaid with a lumber crayon.*

3B PENCIL LITHO CRAYON LUMBER CRAYON MID-GREY
 WASH

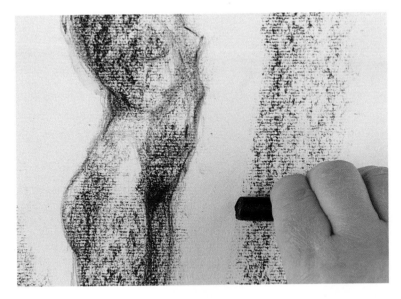

5 *Background details
are represented as basic
tonal shapes and the
drawing is further
refined – the lower part
of the figure merges with
shadows and the upper
torso is revealed as a
darker form against
the light.*

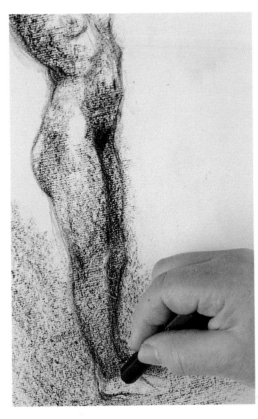

4 *Tonal development continues with the lumber
crayon. The artist needed to exercise considerable visual
judgement to evaluate the tonal balance at this stage.*

6 *Interior details of the
studio are hinted at with
a grey wash applied
with a fine brush.*

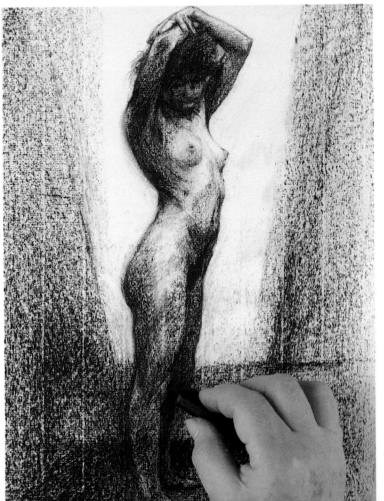

Artist • Gerald Woods

1 *The main forms of the figure are rapidly stated with a 3B pencil on the smooth surface of cream cartridge paper.*

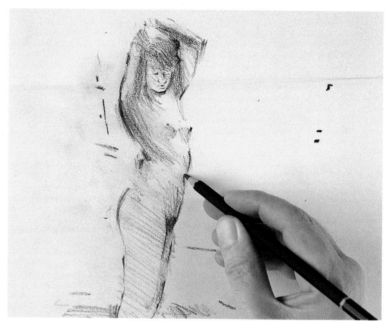

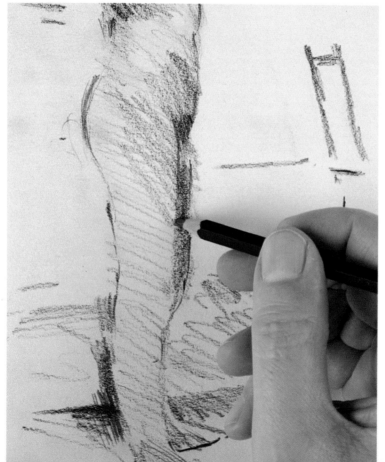

2 *The figure is now more firmly established as further shading is added to emphasise the curvature of the arms, rib cage and torso.*

3 *Modelling of the form continues with a softer 9B pencil; the tones are softened slightly with a finger.*

3B PENCIL 9B PENCIL BLUE-GREY PASTEL FLESH-TINT PASTEL

4 *A blue-grey pastel provides a neutral background tone.*

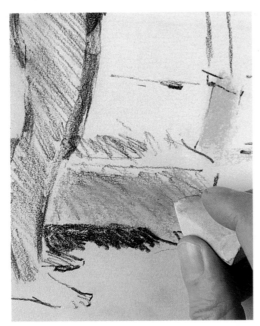

105

5 *A flesh tone is added to parts of the figure with a soft chalk pastel.*

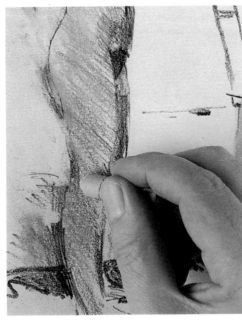

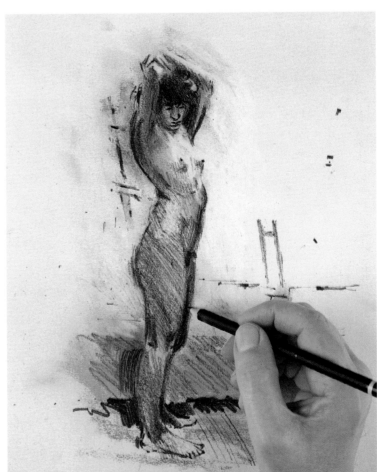

6 *At this stage parts of the drawing have been erased, redrawn and overlaid with smudged pastel. A white wax crayon is used to isolate the figure and cancel out unwanted tone.*

Life Study • *Critique*

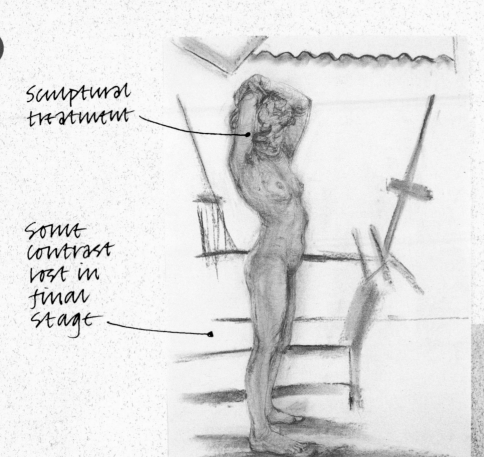

Sculptural treatment

Some contrast lost in final stage

Background details reduced

Angularity of pose well-observed

ROLAND This drawing has been interpreted in a very sculptural way. One has the sense that the artist has used his materials to 'carve out' forms in terms of physical gesture and bodily space. There is nothing static about the drawing; surrounding studio furniture is used as a kind of armature to support the figure in space. The tones have perhaps been levelled out too much in the final stage of the drawing, losing some of the contrast of earlier stages.

ALICE The way that the artist has used a soft wax crayon on a textured, laid paper to produce this sensitive and strongly atmospheric life study recalls the drawings of Seurat. She has captured the angularity and physical presence of the model convincingly. Background details have been reduced to basic, barely perceptible abstract shapes, producing a harmonious tonal relationship.

In relation to the drawings produced by the other artists, the figure appears different in proportion.

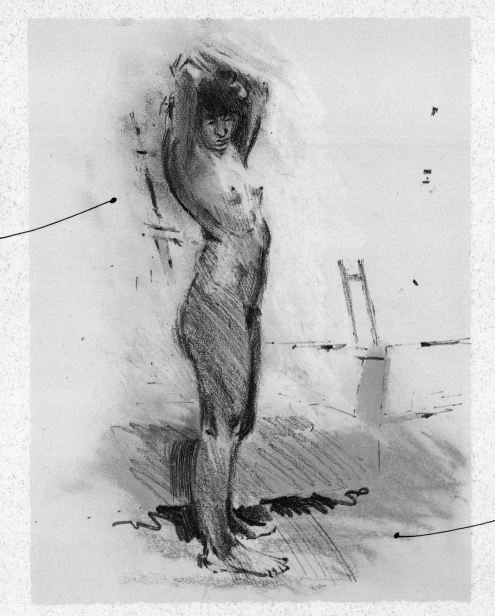

Added use of pastels does not help the drawing

Tone accentuates the articulation of the pose

GERALD This drawing bears the imprint of the artist's constant search for form in a tentative way, rather than with any degree of certainty in the quality of line. Tone has been used to accentuate the articulation of the pose. There is also the sense of balance and distribution of weight, from the curvature of the spine to the feet firmly planted on the studio floor.

I am not sure that the additional use of pastel helps the drawing at all, although a white crayon has been used effectively to cancel out contours that had become too prominent.

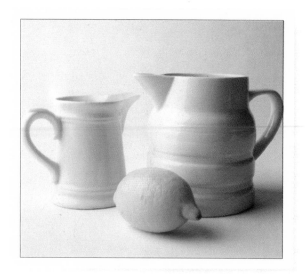

Still Life

JUGS AND LEMON

> *By putting a lemon next to an orange they cease to be a lemon and orange and become fruit* – Georges Braque (1882–1963) ·

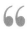In still-life drawing and painting, one is concerned both with the individuality of objects and with their relationship to each other and the spaces between them.

Many beginners find the whole idea of still life rather tedious, possibly because of the connotations the subject has with the schoolroom art exercise. And yet, a perceptive draughtsman can make ordinary objects seem extraordinary. The Italian painter

Giorgio Morandi (1890–1964), for instance, used to search work-shops in his native Bologna for the most mundane oil cans, tin pots, bottles and jars – battered and distorted with age – and used them with great distinction in his still-life paintings.

The fact that an artist is free to select and group objects at will is, to my mind, one of the great attractions of the subject. Complete artistic autonomy is rare in any other painting genre and the degree of control offered by still life can be stimulating.

For this project, two white milk jugs and a single lemon have been grouped together against a white background. The light source accentuates the tonal gradations from light to dark on the rounded forms of the jugs. The lemon adds a touch of colour to an otherwise monochromatic study.

Artist • Roland Jarvis

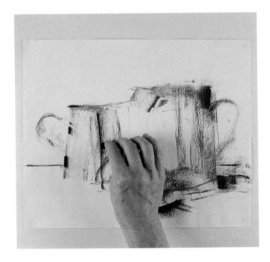

1 *The basic composition is established with a few strokes of charcoal.*

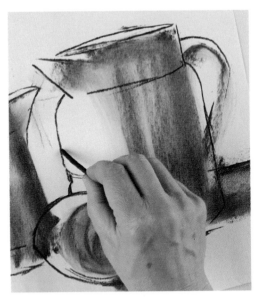

2 *The first tones are softened with a finger and the outline drawn in with a sharpened stem of charcoal.*

3 *Corrections are made at this stage, mainly in terms of tonal contrast, to emphasise the rounded forms of the two jugs and lemon.*

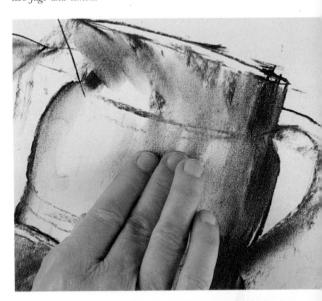

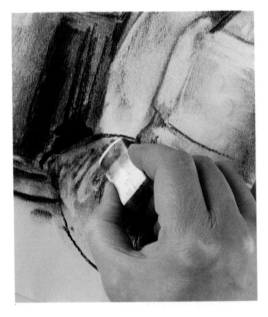

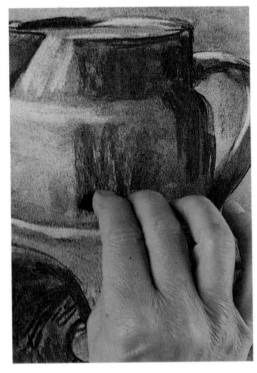

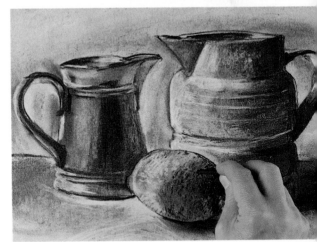

4 *Some shapes are now redefined, after using an eraser to 'carve' light from existing tones, and then re-stating contours with charcoal.*

5 *Background tone is introduced to create a sense of space and to provide tonal harmony.*

6 *The drawing is finally pulled together by producing sharper tonal contrast and adding texture to the lemon.*

Artist · Alice Englander

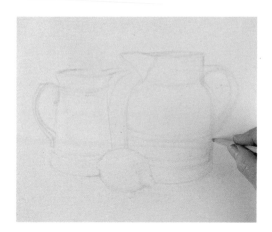

1 *An outline of the still-life group is made with a water-soluble crayon to produce a pale neutral tone as a guide for further progression of the drawing.*

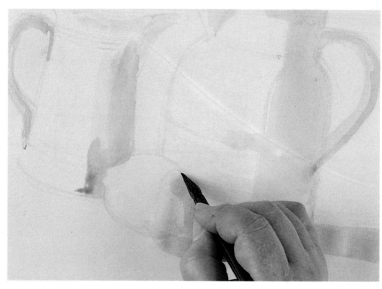

2 *Broad watercolour washes of warm grey are now added to establish tonal values.*

3 *Earlier pencil lines are erased as guidelines are no longer needed.*

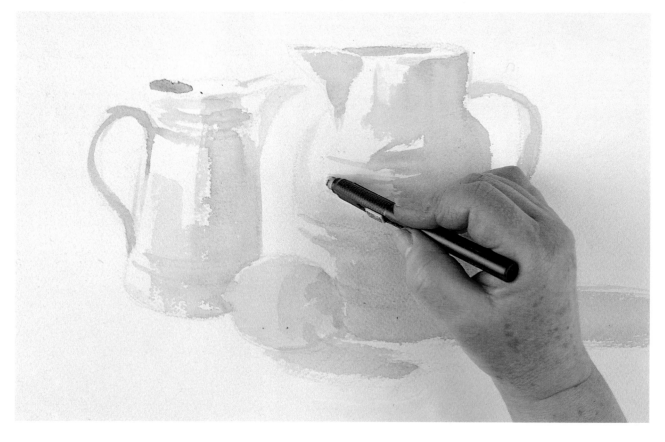

2B PENCIL

WASH OF LAMP BLACK

LEMON YELLOW

BLUE WAX CRAYON

4 *Further tonal modulation continues with blue and grey wax crayons.*

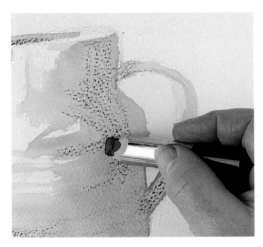

5 *Greater definition is given to forms generally, using a fine sable brush and a wash of Payne's Grey.*

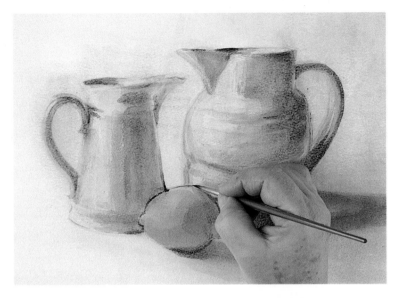

6 *White highlights are added to the jugs with a fine sable brush and white gouache.*

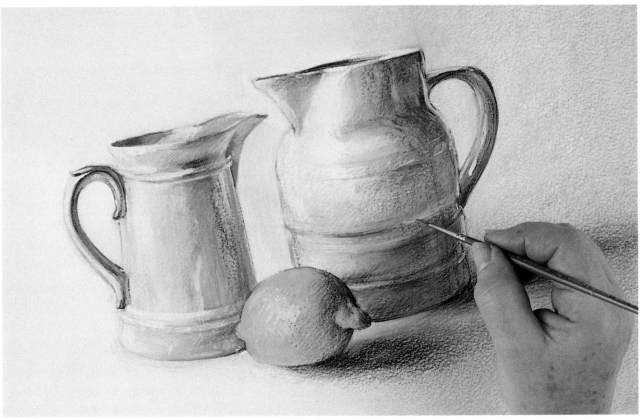

Artist · Gerald Woods

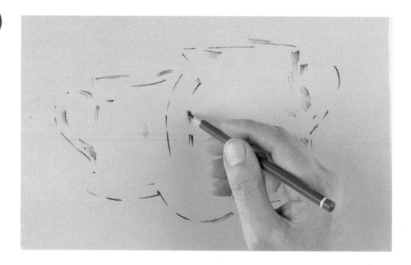

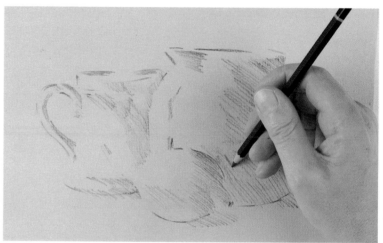

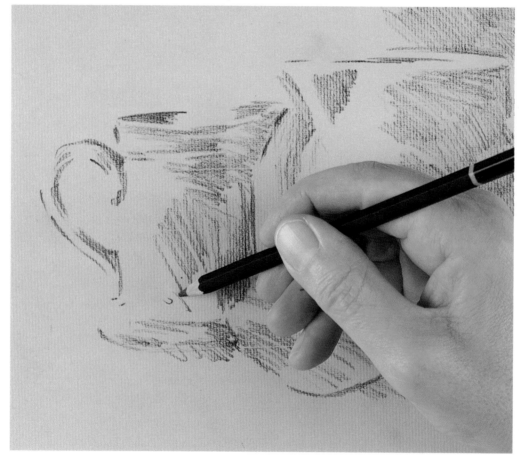

1 *The outline of the two jugs and lemon are stated cautiously with a 3B pencil on buff-coloured Ingres paper.*

2 *Further flat tones are added to suggest the form of the objects. The laid texture of the Ingres paper breaks up the tone of the shading.*

3 *Further tones of soft graphite pencil are applied to objects and background.*

2B PENCIL

3B PENCIL

6B PENCIL

9B PENCIL

113

4 *Shading is now intensified by using a softer 9B pencil.*

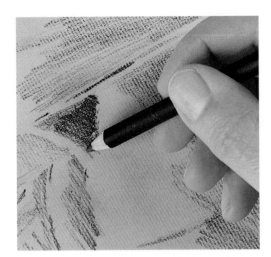

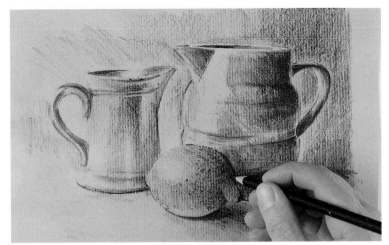

5 *Tones are now blended by using the blunt edge of the 9B pencil. A stippled texture is added to the lemon. The drawing is constructed without conspicuous outlines.*

6 *Highlights are added to the two jugs with a white crayon.*

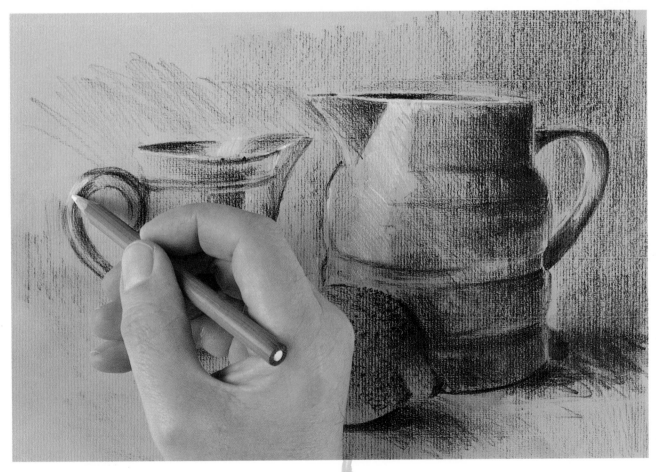

Still Life • *Critique*

Good feeling for light

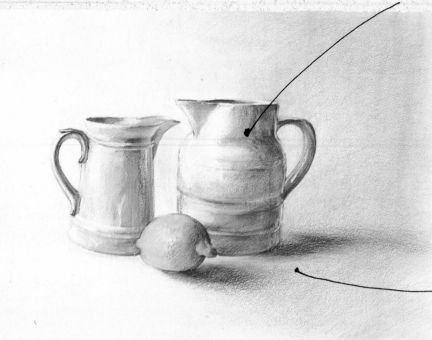

Well-balanced tone

ALICE There is a delightful feeling for light in this drawing. The artist combines watercolour washes with the soft granular shading produced by coloured crayons on textured paper.

It is interesting to follow the sequence from the initial outline drawing and the first washes of watercolour to the final state, where everything is finely honed to produce a convincing representation of the still-life group.

The subtleties of reflected light are difficult to deal with, and the artist has resolved this by getting just the right balance of tone.

GERALD Because it is a subject that is essentially concerned with the play of light on rounded forms, it is perhaps best dealt with in a purely tonal way rather than by using conspicuous outlines. To this extent, the drawing succeeds as a tonal rendering; additionally, the use of coloured paper enhances the tonal values.

My only criticism is that perhaps the whole drawing is a little too safe; there could, for instance, have been more evidence of the search for form.

Too safe – the drawing could have been more searching

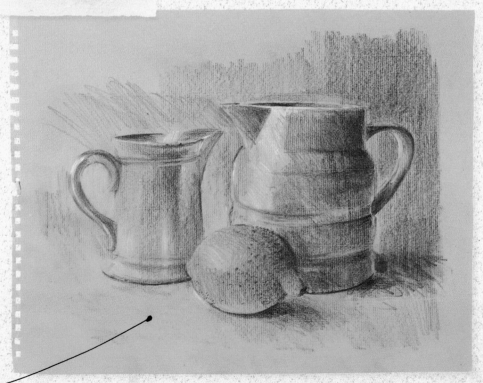

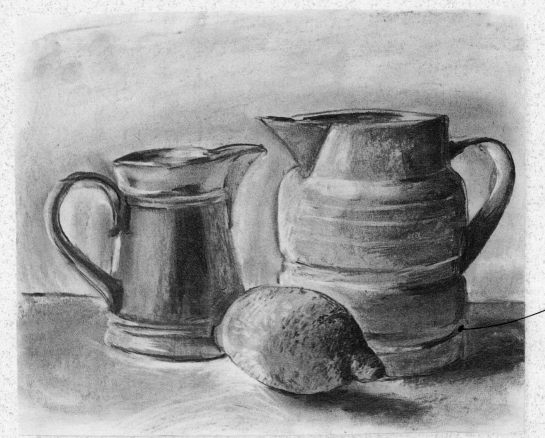

Essential qualities of subject clearly stated

ROLAND What this drawing demonstrates more than anything else is the need to go beyond mere outline and shading to uncover the essence of the subject. One has the sense of the artist using charcoal to convey the feeling that these are objects that have been picked up, walked around and examined with great care.

Again, from a subjective point of view, I much prefer the drawing in its penultimate stage to the final statement.

Nature Study

TREES IN WINTER

In this project, the artists are required to draw the gaunt tracery of trees in a fog-laden winter landscape. Guessing plays an important part in our perception of nature. In fog especially it is difficult to define the exact shape of things and what we cannot see we tend to manufacture. In this instance, the fog has the effect of reducing everything to a kind of two-dimensional pattern.

When drawing trees, try to forget any preconceived ideas you may have about what things look like. Notice carefully the shape of the trunk and how individual branches are formed. Use a drawing technique which will help you to unify all the parts, such as graded soft pencil strokes or cross-hatching. The skeletal shapes of trees that have shed their leaves are, of course, quite different from the trees one sees in high summer, when the foliage fills out and forms the predominant outer shapes. Always go for the main and secondary shapes, and forget about individual leaves. If, however, you have a tree in your composition in the immediate foreground, you can pick out individual leaves as a means of suggesting distance.

Certain specimens of deciduous tree – horse-chestnut, for example – might be best drawn in midsummer, when the full bloom of foliage lends a voluminous quality to the landscape scene. Remember that in sunlight the shadows and patterns of light cast by the form of a tree are as important as the tree itself to surrounding elements.

Artist • Roland Jarvis

CHARCOAL

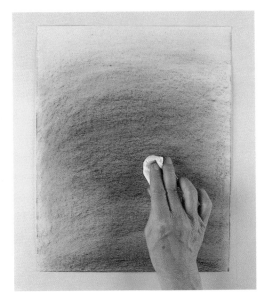

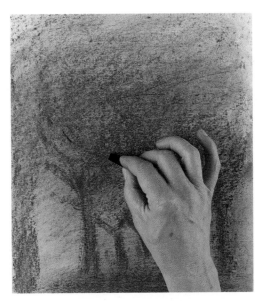

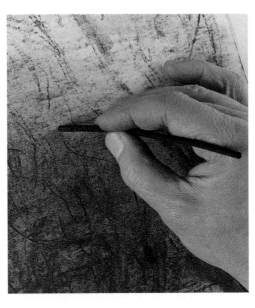

1 *A general background tone is created with a block of charcoal. The pigment deposition on the paper is then gently brushed with tissue paper.*

2 *A slightly darker tone reveals the position of the trees and lower branches.*

3 *By applying more pressure on the charcoal, the trees in the foreground are given more definition.*

4 *Lights are picked out with a putty rubber and the upper branches are added at this stage.*

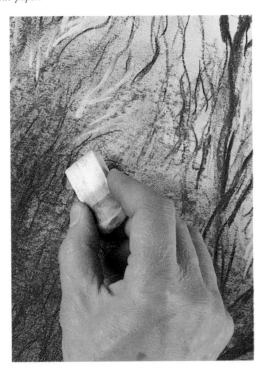

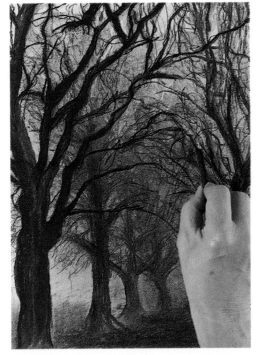

5 *The sense of distance is evoked by the separation of tone, the trees in the foreground being darker in tone than those in the middle-distance. The complexity of the tracery of the branches is handled convincingly in the final stage, producing a sense of atmosphere appropriate to the scene.*

Artist · Alice Englander

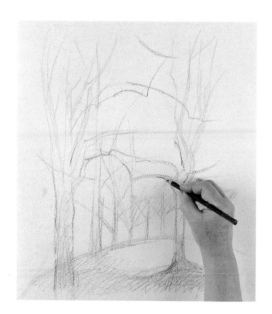

1 *A rough outline sketch is made of the main tree forms using a water-soluble blue-grey crayon.*

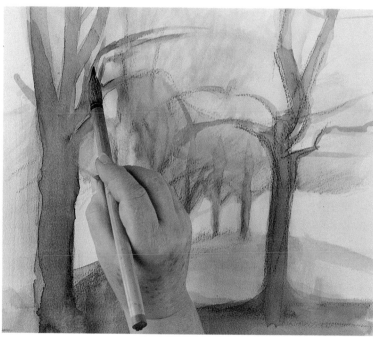

2 *The water-soluble crayon is dissolved with a wet Chinese brush to produce a pale wash which establishes primary tonal values.*

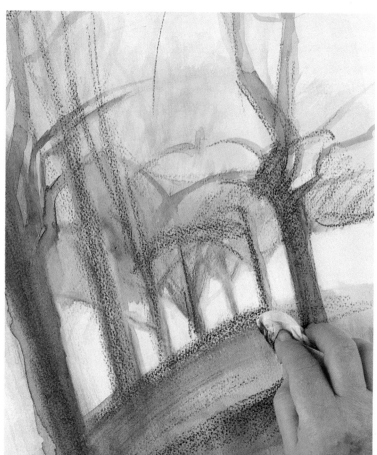

3 *While still wet, parts of the wash are blotted with tissue to produce a paler tone.*

5 *Details of the trees are heightened and a gradation of tone from black in the foreground to pale grey in the middle-distance is established.*

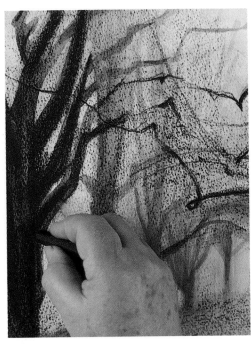

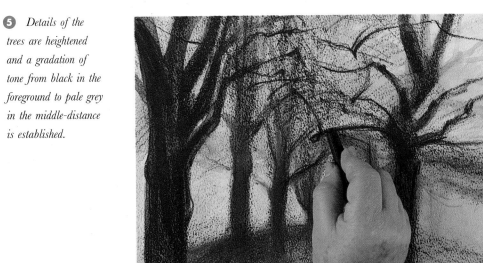

4 *The trees on the left and right in the foreground are redrawn using a black wax crayon. This creates a strong granular tone which is also added to other parts of the drawing.*

6 *A white wax crayon is used to soften tones and to enhance the general wintery atmospheric quality of the drawing.*

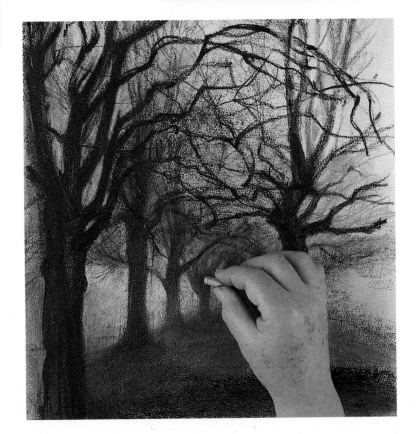

Artist • Gerald Woods

1 *The position of the main tree forms are sketched in with a soft charcoal pencil on white cartridge paper.*

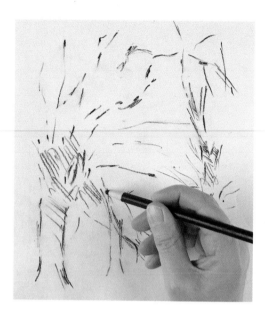

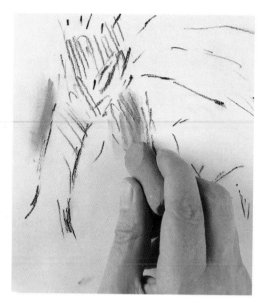

2 *A neutral tone of pale mauve pastel emphasises selected forms of the branches.*

3 *Further background tones are added with a darker mauve pastel although colour here is largely symbolic rather than actually perceived.*

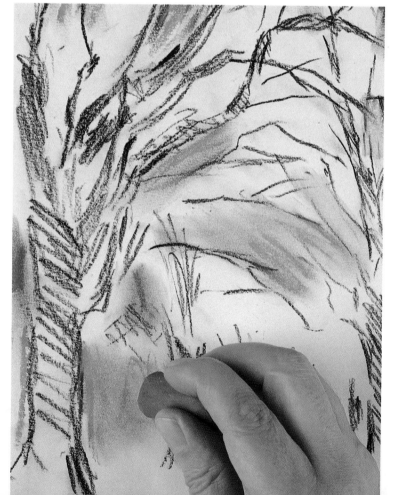

CHARCOAL PENCIL PALE MAUVE PASTEL DARK MAUVE PASTEL CHARCOAL 9B PENCIL BLUE-GREY PASTEL

4 *The tone on the tree trunks is intensified with charcoal. This stage is then fixed before continuing with the drawing.*

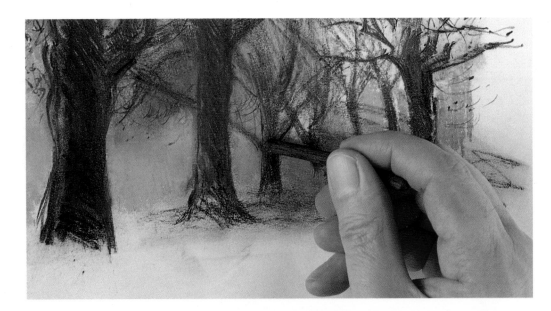

5 *The trees are re-drawn with a 9B pencil. Additional tones of blue-grey pastel provide the fog-laden atmosphere in the foreground.*

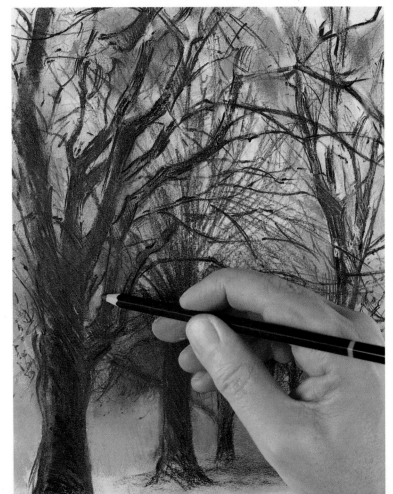

Nature Study · *Critique*

122

GERALD In this drawing, the artist has explored to some extent the essential abstract values of the composition. The branches are drawn to enclose tentative patches of colour, which are imagined rather than perceived. By emphasising the basic charcoal lines with multiple contour lines drawn in pencil, he has managed to hint at the organic nature of the tree forms. Corresponding rhythms in the tracery of the branches have been noted and sometimes accentuated.

This project reveals just how much guesswork plays in our perception, particularly in fog, or towards dusk, when definition is less certain.

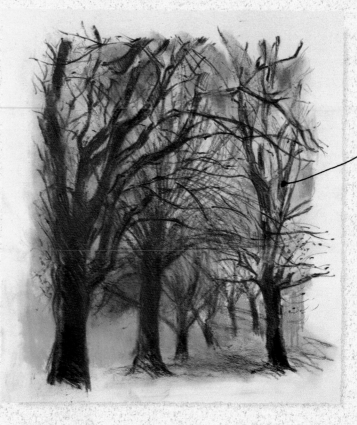

Pencil emphasises charcoal line

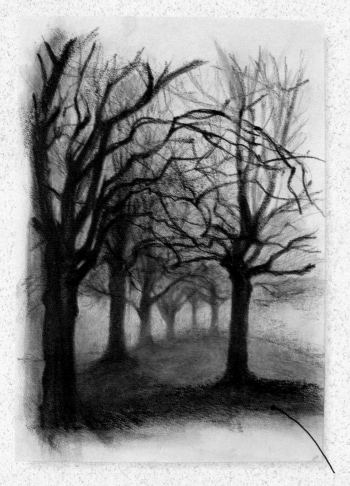

ALICE Any drawing of trees in winter must necessarily be a summation of detail. Because of the complexity of the trees' structure, the drawing is largely symbolic; the artist represents certain details and characteristics which will distinguish one species from another. In this instance, most concentration has been given to the tree form on the left-hand side of the composition. The branches of this tree link and to some extent envelop other parts of the composition.

The tonal recession in the drawing has been handled particularly well, as has the sense of distant forms being less distinct as they become shrouded by winter fog.

Tonal recession handled well

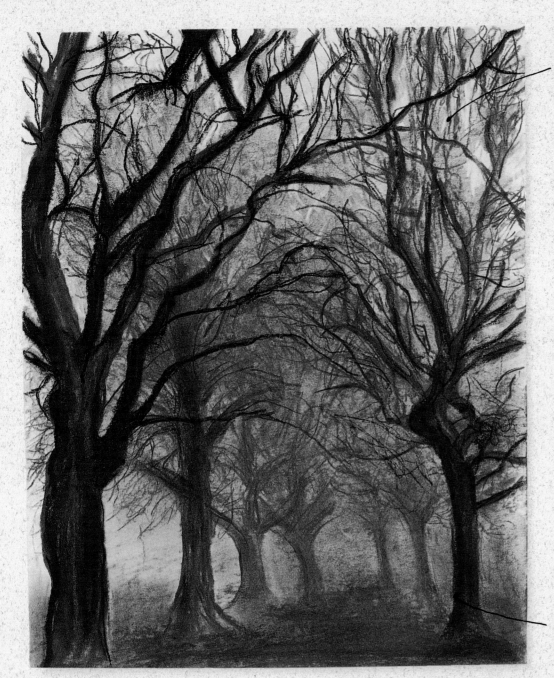

convincing
expression
of atmosphere

rich
scale of
tone

ROLAND This strongly atmospheric drawing has been produced by a layered charcoal technique, which requires each stage of the drawing to be fixed before proceeding to the next. By working in this way, the artist avoids the problems caused by smudging, or brushing against the charcoal pigment that has already been deposited on the paper. The final state of the drawing, therefore, reveals a rich scale of tone from intense, velvety blacks in the foreground, to softer, barely perceived tones in the distance.

Again, the trees and their branches in the foreground serve to frame the rest of the drawing.

Change of Scene

THE TAJ MAHAL

With most travel, the more leisurely the manner in which one proceeds, the richer the experience. Today, however, affordable air travel has meant that artists are able to spend a week or so each year travelling to exotic locations in search of fresh and stimulating experience.

The Taj Mahal in Agra, India, is one of humanity's greatest architectural and aesthetic achievements. Built by Shah Jahan as a tomb for his beloved wife Mumtaz Mahal, its construction began in 1630, and it took 20,000 craftsmen 23 years to complete. It is built of brick clad with white marble inside and out and inlaid with precious stones. The mausoleum stands on a huge square platform and is guarded by four slender minarets which lean slightly inwards. The dome is almost 60m/200ft high. The approach to the Taj is along a cypress-lined waterway which reflects the pale splendour of the dome and minarets. Shah Jahan intended to build a second mausoleum in black for his own tomb. It was to stand at the end of the waterway, facing the Taj Mahal. Unfortunately, he ran out of money.

It is, of course, quite impossible for any artist to produce a satisfactory rendering of this building. But by focusing on the unique spatial and structural elements, one can gain a better understanding of the exquisite proportions of the building and use this understanding as a basis for producing a picture characterised by its strong composition.

In his *Leaves from a Notebook*, Thomas Aldrich once said, 'I like to have a thing suggested rather than told in full when every detail is given, the mind rests satisfied, and the imagination loses the desire to use its own wings.' The task, therefore, for anyone drawing such a building is, in my view, to go for understatement – to allow the imagination to take flight.

Artist • Roland Jarvis

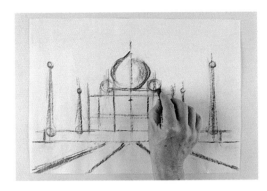

1 *The main proportions of the building are roughly indicated with charcoal. Parallel paths in the foreground are rendered in perspective to suggest distance.*

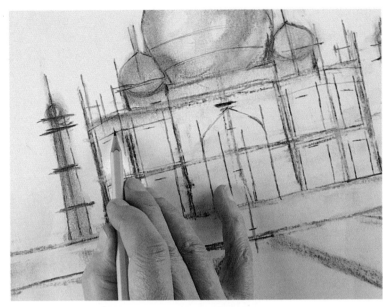

2 *The rounded forms of the domes and cylindrical towers are developed in charcoal, and the surface pigment smudged with a finger. The space between features, such as the windows and arches, is marked with pencil.*

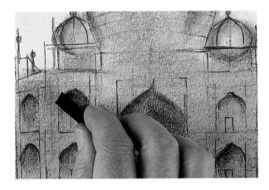

3 *A soft tone of blended charcoal creates atmosphere and shadows are added after fixing the first tone.*

4 *The drawing is now developed in terms of tonal contrast – with the darkest tone in the foreground.*

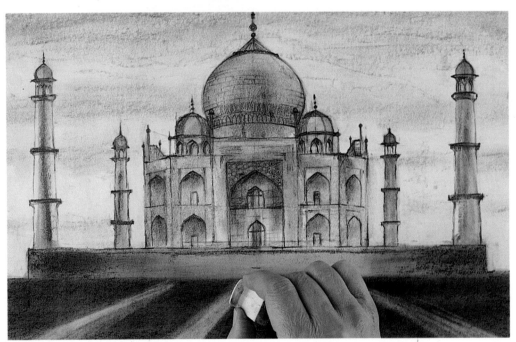

5 *Highlights are picked out with a putty rubber. Decoration on the façade and the main dome is drawn with a sharpened 3B pencil. The outline of two figures seated in the foreground is also drawn in the final stage.*

Artist · Alice Englander

1 *All the basic symmetry and structure of the building is established, using a metre stick.*

2 *The main domes and arches are drawn in a neutral colour grey crayon on cartridge paper.*

3 *A wash of Payne's Grey water-colour is applied with a Chinese brush to isolate the main forms of the building and indicate tonal values.*

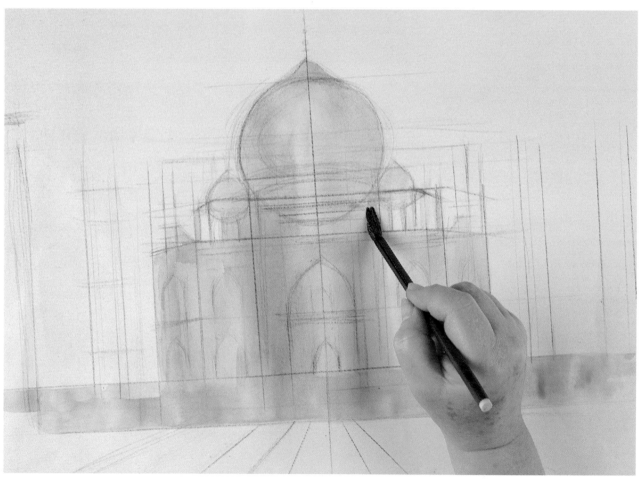

NEUTRAL GREY
CRAYON

PAYNE'S GREY
WASH

PAYNE'S GREY

INDIGO CRAYON

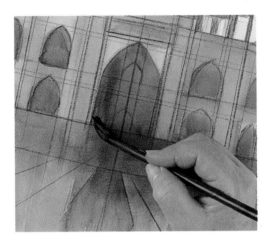

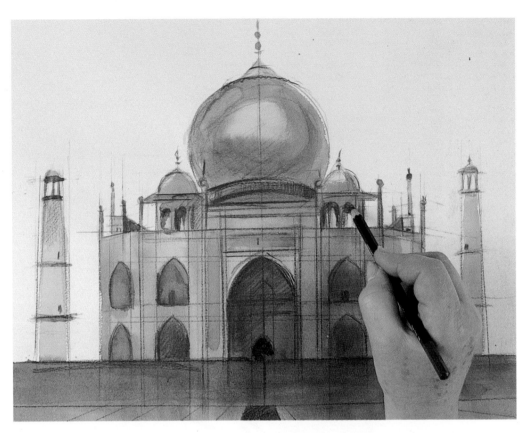

4 *Further darker tones of the same colour (Payne's Grey) are added to the recesses of the building.*

5 *Architectural detail on the arches, towers and recesses is suggested with a dark blue crayon.*

6 *Highlights on the façade of the building are picked out with a white wax crayon.*

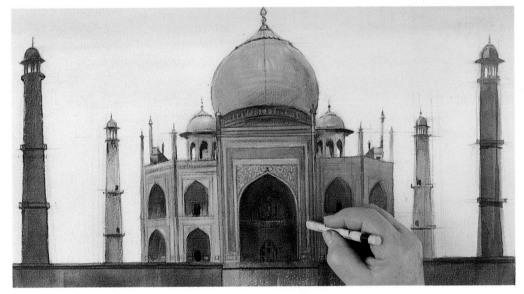

Artist • Gerald Woods

❶ *Using a 3B pencil on white cartridge paper, the basic proportions of the domes and towers are indicated with a few tentative marks.*

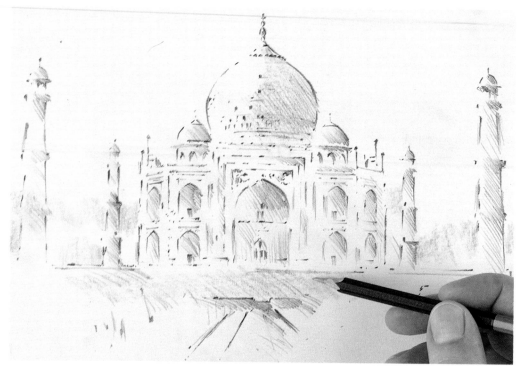

❷ *The drawing is further consolidated by evaluating light and dark areas. A mid-grey pencil provides an additional tone to heighten the atmosphere of the drawing.*

❸ *Delicate shading is overlaid on the façade with a blue crayon.*

❹ *Tints of pink and purple are added to the sky with coloured pencil.*

 3B PENCIL

GREY CRAYON

 BLUE CRAYON

PINK CRAYON

 PURPLE CRAYON

 6B PENCIL

 GREEN WAX CRAYON

129

5 *Using a softer 6B pencil, tones are intensified and further tints added with coloured crayons. Contours are deliberately understated to allow the building to emerge from soft hues.*

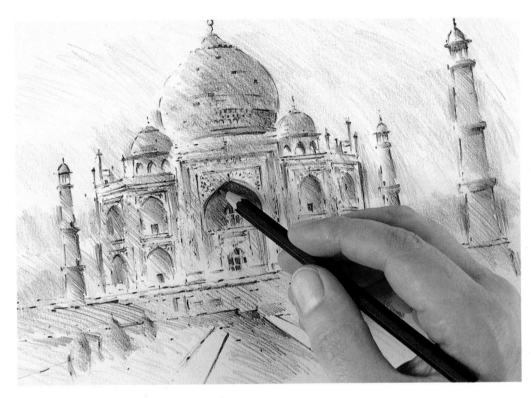

6 *Green shading is added sparingly to bushes and grass in the foreground with a wax crayon. The complete image suggests a fleeting impression rather than a detailed architectural study.*

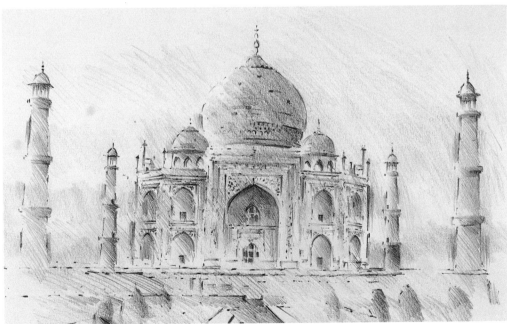

Change of Scene • *Critique*

Restrained line reveals emotional response

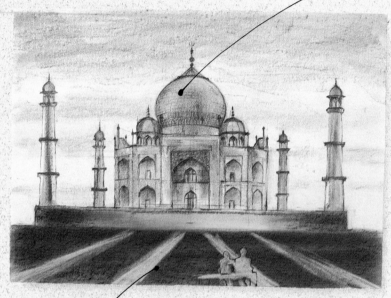

seated figures convey scale

ROLAND This is the kind of drawing that leaves space for one's own imagination. The rendering of too much information in terms of architectural detail can sometimes be over-bearing at the expense of other values. What is essential in drawings of this kind is that the line does more than transmit the information – it must also reveal an emotional response to the subject.

The two seated figures in the foreground lend a sense of scale to the drawing and, by their isolation, add a meditative note.

Contrasts of light and shadow work well

ALICE In my view any drawing of the Taj Mahal needs to convey something of the tranquillity and serenity this building is reputed to inspire. This drawing, I feel, does succeed in that respect; the effect of the building in shadow against a back light works particularly well. Moreover, the symmetrical harmony of the main building and outer towers have been drawn in such a way that they suggest that it is a place of contemplation and silence.

The inclusion of some trees and shrubs in the foreground might have relieved the overall greyness of the composition without distracting too much from the values already stated.

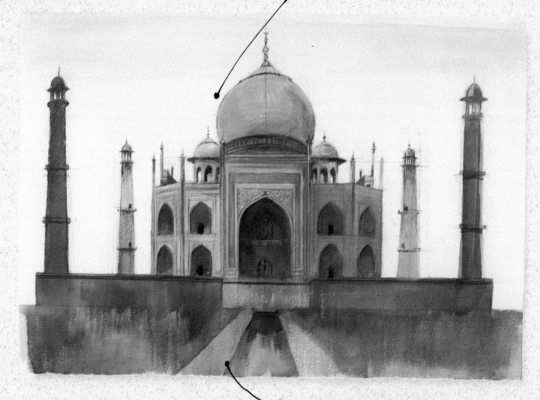

Foreground needs something to relieve composition

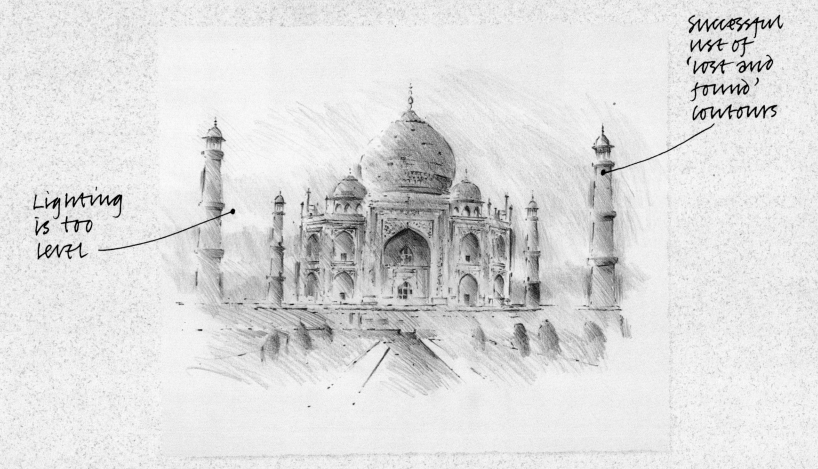

successful use of 'lost and found' contours

Lighting is too level

GERALD The artist has successfully used the technique of 'lost and found' contours to produce a resonant study of the Taj Mahal. Decorative architectural detail on the façade of the building is hinted at rather than overstated. The spatiality of the particular setting is also evoked by just a suggestion of paths and greenery seen in perspective in the foreground.

My own feeling, however, is that the lighting is perhaps too level – architectural subjects are often best seen in early morning or towards dusk, when the quality of light heightens the monumental aspect of buildings.

Landscape

STOPHAM BRIDGE

In every country the best examples of historic architecture usually incorporate locally quarried stone and clay. The timber used for building is also cut from nearby forests. This ensures a visual affinity with the surrounding landscape, as in the case of the bridge selected for this project.

Stopham Bridge was originally built in 1423, although the raised centre arch dates from 1822. The other six arches provide a rhythmic link from one side of the river to the other, which is visually satisfying. In this scene, the bridge makes a bold horizontal statement relieved only by the gently contrasting reeds and grasses in the foreground and the hazy green tracery of distant trees.

Texture is an important aspect of this subject. We are sometimes so preoccupied with representing what we see in terms of line and tonal contrast that we tend to overlook the rich texture of various substances which have become weathered and burnished by centuries of exposure to the elements.

Artist · Roland Jarvis

BURNT SIENNA
CONTE

BURNT SIENNA
WASH

BURNT SIENNA
DARK WASH

GREY WASH

BLACK CONTE

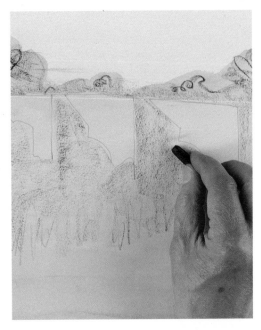

1 *A lucid outline of the distant trees is drawn with a Burnt Sienna crayon.*

2 *A wash of Burnt Sienna is applied over the whole of the foreground and middle-distance and areas of shadow, foliage and vegetation are tentatively drawn with black conté crayon.*

3 *The shadows of the arches and projecting buttresses are formed as a transparent wash of grey is overlaid on to the Burnt Sienna ground.*

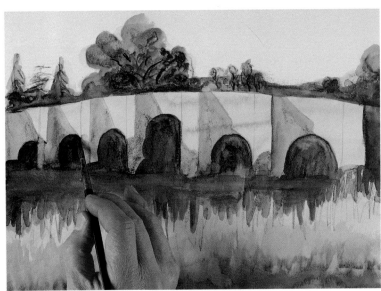

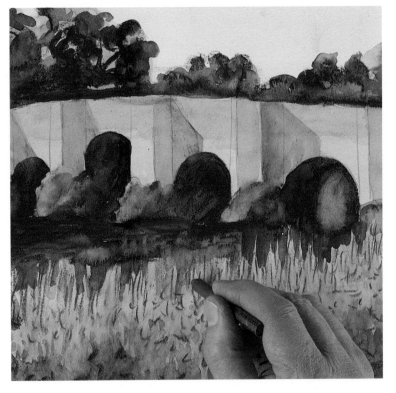

4 *Darker shadows are added to the arches under the bridge, the trees and river.*

5 *Texture is added to the grasses on the river bank. A pale wash is applied for both the sky and the stonework of the bridge.*

Artist • Alice Englander

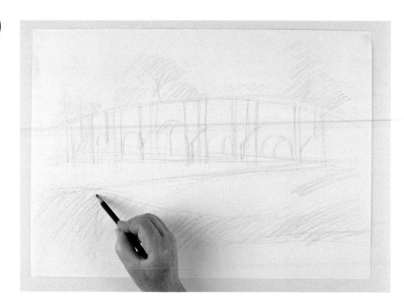

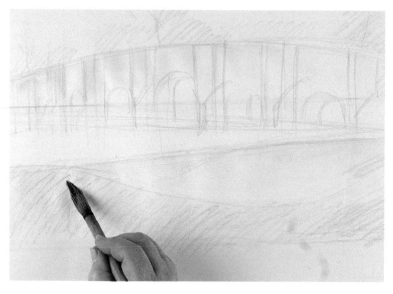

❶ *An underdrawing of the bridge and surrounding foliage is produced with a crayon of a neutral tint on heavyweight cartridge paper.*

❷ *Pale washes of watercolour are applied wet-in-wet with a large Chinese brush.*

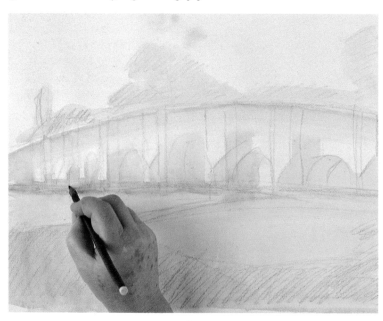

❸ *Here the artist uses a finer Chinese brush to add a mid-tone of watercolour to the arch of the bridge.*

❹ *A yellow wax crayon is used as a base colour for the grass on the river bank.*

PURPLE CRAYON

LEMON YELLOW
WATERCOLOUR

VIRIDIAN
WATERCOLOUR

BLUE CRAYON

BLACK LUMBER
CRAYON

5 *Here the artist has used a heavy wax lumber crayon. This produces a denser granular atmospheric tone on the bridge and distant trees. Further drawing is done on the stonework and under the arches of the bridge with the lumber crayon.*

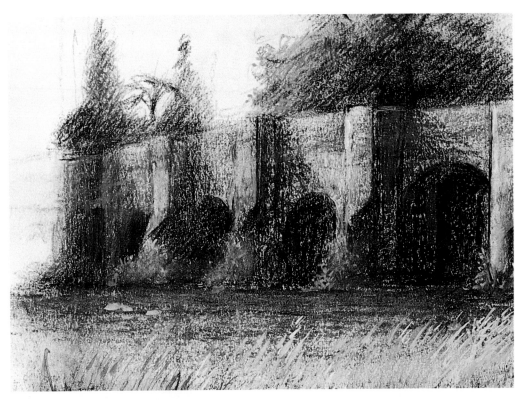

6 *Reeds and grasses on the river bank are drawn with a No. 1 sable brush.*

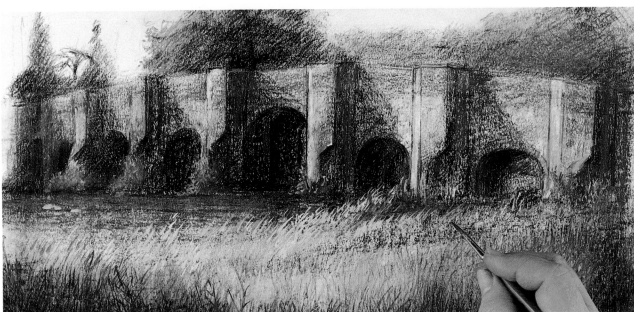

Artist • Gerald Woods

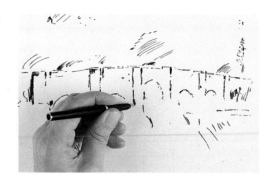

1 *The main proportions of the bridge and stonework are drawn with a fountain pen filled with a water-soluble black ink. A few random strokes of the pen also suggest distant foliage and grass on the riverbank.*

2 *Shading is introduced alongside supporting buttresses and surrounding vegetation.*

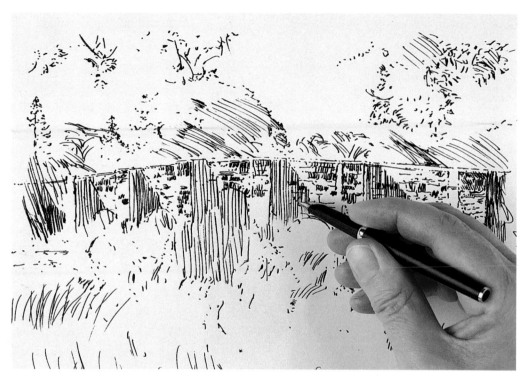

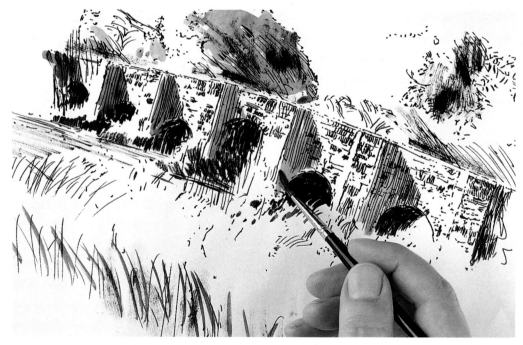

3 *Applied with a No. 3 sable brush, a dilute wash of Indian ink provides half-tones and shadows. A more solid black forms the intense shadows under the arches.*

FOUNTAIN PEN INK WASH OCHRE CRAYON PURPLE CRAYON

4 *The drawing is more fully developed using successive strokes of the pen and dry brushwork. After some parts of the drawing have been marked off, spatter is added with an old toothbrush and ink.*

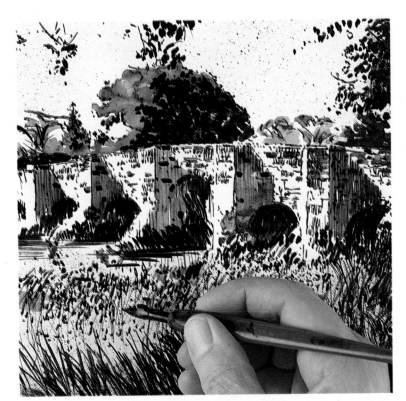

5 *A tint of ochre is drawn sparingly on the riverbank and on part of the bridge.*

6 *A tint of purple crayon is added to the sky and is blended with other colours.*

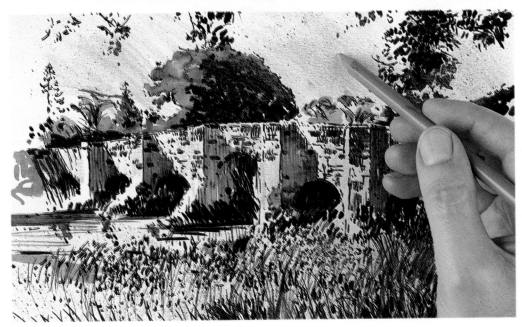

Landscape · *Critique*

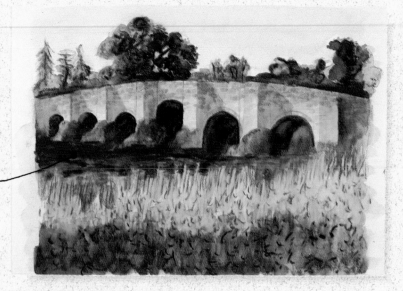

composition is helped by strong tonal contrasts

ROLAND Man-made structures in the landscape, such as this bridge, need to be drawn as if they are growing out of the ground on which they stand.

This drawing demonstrates how black and a second coloured tint can be used effectively to produce greater depth and an interaction of warm and cool values which control the design. It is a forceful composition with strong tonal contrast suggesting the material substance of the stone bridge.

Bridge and landscape well integrated

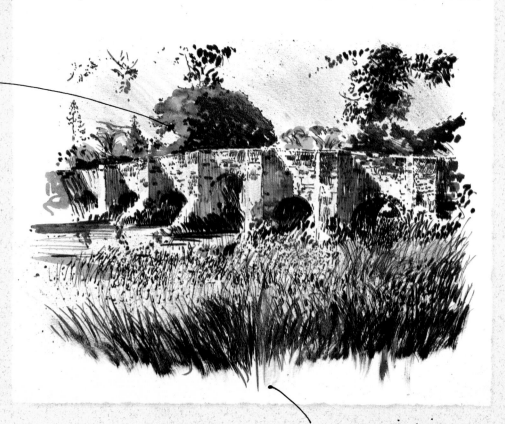

GERALD In this graphic rendering of the subject, the artist has combined pen and ink, wash, dry brushwork and spatter to create a unified sense of the place and its particular quality of light. The integration of the bridge with the landscape works well and there is considerable variety in the marks made to suggest the texture and character of surrounding vegetation.

Compositionally, it is perhaps too symmetrical and the drawing could have been made more dramatic by extending either the sky or foreground and by providing more contrast.

composition too symmetrical

Elements harmonise well

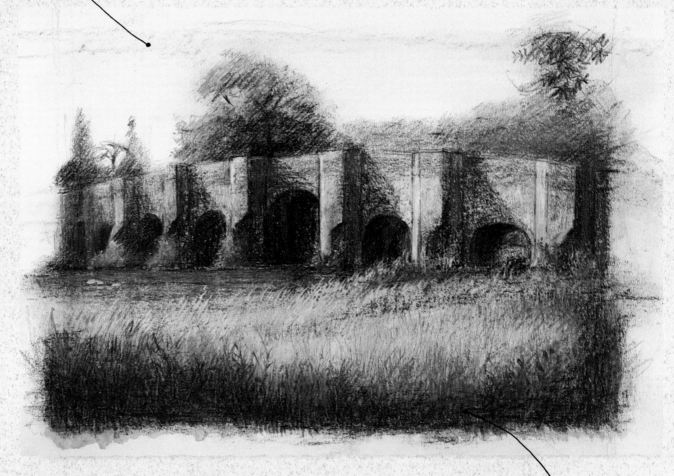

Good use of contrasting textures

ALICE The artist has avoided the potential trap of producing a picturesque rendering of this subject. It is a drawing where all the elements work together harmoniously. Everything necessary to the idea is included without the addition of extraneous detail. There is an interesting contrast between the solidity of the bridge and the almost gossamer-like quality of the wild grasses on the riverbank.

Glossary

 A

AERIAL PERSPECTIVE

The effect caused by the density of the atmosphere as objects recede towards the distance. This results in colours and tones becoming muted and hazy, with a tendency towards blue in distant parts of the landscape.

ATMOSPHERE

Relates to the suggested recession in a painting achieved with changes in colour and tone between the background and the foreground.

B

BLENDING

The merging of colours or tones together with a brush, torchon or fingertip so that no sharp edges are visible.

BODY COLOUR (SEE GOUACHE)

C

CALLIGRAPHY

The consideration of handwritten letterforms as a craft or art form.

CHARCOAL

Charred sticks of willow or vine which are used for drawing.

 CHIAROSCURO

Derived from the Italian 'light-dark' used to describe the effect of graduated shading in a drawing.

COMPOSITION

The visually satisfactory arrangement of all the related elements in a drawing or painting.

CONTÉ

A hard French crayon named after its inventor – they are produced in a limited range of colours.

CROSS-HATCHING

Layers of crisscrossed parallel lines produced with pen or pencil as a form of shading drawings.

D

DRY-BRUSH

A technique in which the paint or ink is largely undiluted and brushed lightly over the surface of the paper to produce a broken texture.

E

EASEL

A supportive stand for a drawing board or canvas – it is usually made of wood, though collapsible models are made from metal.

 F

FIGURATIVE

A term which represents the artist's intention of producing drawings of recognisable objects as distinct from abstract interpretations of the same objects.

FIXATIVE

A thin colourless varnish which is sprayed onto the surface of a drawing to make it stable i.e. to prevent the pigment from coming off the paper or smudging.

FORESHORTENING

Perspective applied to a single object. If for instance, a hand is pointed directly towards the viewer, it would be seen to be strongly foreshortened as only the extremities of the fingertips would be clearly visible.

FORM

A term which refers to the three-dimensional appearance of a shape.

 G

GOUACHE

An opaque water-soluble paint – also known as body colour.

GRAPHITE

A type of drawing pencil in which the lead is produced from a combination of carbon and clay.

GROUND

As in coloured ground – usually the first colour laid on the paper as a preliminary tone. Could also refer to coloured papers used for drawing.

 H

HALF-TONE

A tone that is seen to be mid-way between black and white, or the strength between the darkest and lightest tone.

 I

INDIAN INK

An intense black ink available as a water-soluble ink or as a waterproof ink.

 M

MODELLING

The way in which the volume and solidity of an object is expressed through drawing in terms of light and shade.

MONOCHROME

Refers to a drawing or watercolour done in a single colour or in tones of black and white.

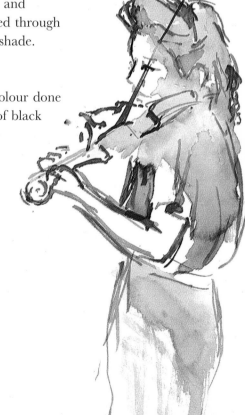

142

PERSPECTIVE

A means of recreating objects through drawing so that they have the illusion of three-dimensions, or appear to have depth, on a two-dimensional surface. Linear perspective makes use of parallel lines which converge on a vanishing point.

PICTURE-PLANE

The imaginary space or plane where a picture begins, in other words the surface of the picture. Where perspective is applied, forms may appear to project, or recede from the picture-plane.

SCALE

The relative size of objects within the drawn composition – in proportion to each other.

SILVERPOINT

An ancient drawing technique using a silver-tipped instrument on a specially prepared paper to produce delicate tones of grey.

SUPPORT

The surface on which a drawing or painting is made.

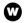

TONE

The term used to describe light and dark values in a drawing or painting; for example pale blue is a different colour to pale yellow, but both may have the same tone.

VANISHING POINT

In perspective – a point on the horizon line at which all the receding parallel lines appear to converge.

WASH

Dilute watercolour or ink, applied to the paper in a way that allows it to spread (in a controlled or uncontrolled action) as a transparent film.

WATERCOLOUR

A water-soluble paint made from pure coloured pigment bound in gum and glycerine.

WET-IN-WET

A watercolour technique which involves adding one colour to another which is already wet, so that they merge into one another.

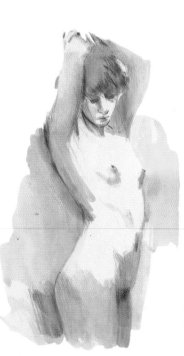

Index

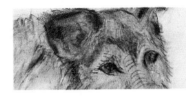

143

Index

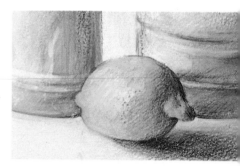